IMAGES
of America

DOWNTOWN
CULPEPER

IMAGES
of America

DOWNTOWN
CULPEPER

Diane Logan
Culpeper Renaissance, Inc.

ARCADIA
PUBLISHING

Published by Arcadia Publishing
Charleston SC, Chicago IL, Portsmouth NH, San Francisco CA

Printed in the United States of America

Library of Congress Catalog Card Number: 2006938294

For all general information contact Arcadia Publishing at:
Telephone 843-853-2070
Fax 843-853-0044
E-mail sales@arcadiapublishing.com
For customer service and orders:
Toll-Free 1-888-313-2665

Visit us on the Internet at www.arcadiapublishing.com

This book is dedicated with admiration and humility to
the strength of character of the people of Culpeper.

CONTENTS

ACKNOWLEDGMENTS

The following sampling of Culpeper life would not have been possible without the encouragement of the board of directors of Culpeper Renaissance, Inc. (CRI), and its president, Carol Inskeep. As the Culpeper Renaissance, Inc., board looked back on the past 20 years of its history, it became evident to everyone that the success of today's downtown is due to the same dedication, determination, and strength of character that is the heart of Culpeper.

My first introduction to the incredible story of the people of Culpeper was several years ago at the Battle of the Wilderness reenactment. It was here that I met Virginia Morton. Her enthusiasm and passion for the story of war-torn Culpeper made it impossible for me not to read her novel *Marching Through Culpeper*. With each page, I gained more and more admiration and respect for this community. I was given the opportunity to relocate here in 2001.

Thank you to the Lee Langston-Harrison, Tom Huggard, and the staff of the Culpeper Museum of History for their assistance. The majority of the photographs reproduced here are from the Guinn Collection housed at the museum. Many of the photographs from this collection were published in the mid-1970s by William Elder Jr. That publication has been used as a guide and resource for this publication.

Thank you to the Kinzer family, Alan's Photography Studio, the State Theatre Foundation, John Lassiter, and the many community residents who shared photographs and postcards for publication.

Thank you to local historian Zann Miner for her encouragement and the many conversations on Culpeper history. Through a grant from the Culpeper Community Foundation, she became a consultant on this project. As the project's historical consultant and researcher, Zann spent many hours reviewing photographs and researching data to confirm its authenticity. The quality of this publication is due in large part to her professionalism and love of Culpeper history. She is an inspiration in her continued work with preservation and historical groups.

A huge bear hug of a thank you to Jessie Wise for "loaning" me his daughter, Jessica, for "an interesting project." Jessica worked hours scanning photographs and documenting captions. Even with a broken ankle and leg, she saw the project through.

Lauren Taylor joined the team in the last stages of production. Without Lauren's guidance and layout expertise, this project could not have been accomplished. Also a huge thank you to the CRI staff for assisting with the many tasks of putting together these images for publication.

Looking at photographs at random can give one a sense of place or of a people. However, looking upon a grouping of family photographs tells a story. I have included a collection of photographs that tells the story of a Culpeper family that has contributed to the community for many generations. A very special thank you to David F. Kinzer III and to Julia Smith for sharing their treasures with us.

Several publications on Culpeper history were used as resources. One of the most valuable to me was Donnie Johnson's *Culpeper, a 20th Century History*.

Last but not least, thank you to my husband, Gary, for pushing, prodding, and nagging me to use my creative mind to begin at least one of the many projects on my "to do list before I die." He also became the technical partner and spent many hours scanning and laying out the book for publication. Images of America: *Downtown Culpeper* is not intended as a history of the community but merely as an offering of images of Culpeper, "the one and only," in hopes that it will inspire a sense of heritage and preservation in the Culpeper community.

INTRODUCTION

Culpeper was established as a rural county seat with the courthouse occupying the center of town. The earliest settlers to the wilderness of this part of Piedmont Virginia now called Culpeper came to find a better life for their families. They carved the beginnings of a community that has withstood the ravages of Mother Nature, the horrors of war, and the changing economy. Today descendants of those early settlers and those of us who have chosen to relocate to this special place face the challenge of preserving the rural beauty that surrounds the downtown and the cultural and social fabric that has made Culpeper one of the best small towns in America.

Naturally the commercial center developed around what are now Main and Davis Streets. As the area grew, people began moving to town, building beautiful homes that are still here today.

With the opening of a stagecoach route in 1834 and the Orange and Alexandria Railroad in 1853, Culpeper's downtown became a major trading and shipping point in the Piedmont region of Virginia. Hotels, commercial enterprises, and warehouses gradually migrated to the depot area.

According to Civil War historians, Culpeper was the best vantage point from which to observe America's deadliest war. Strategically located, the county saw more troop movement than any other locale in the nation. Lee considered it a natural camping ground for the Confederate army. From Culpeper, he could move quickly to Richmond or to the Shenandoah Valley. It was an ideal point of invasion for the Union army en route to Richmond.

Even the downtown was not spared from the flying bullets and thundering hoof beats of a battlefield. Though not the cavalry engagement of Brandy Station, downtown East Davis Street was the scene of Custer's charge on the depot. It was here that Custer received his only wound during the war. Upon his recuperation, he returned to Culpeper with a new bride.

The downtown was frequently visited by both Union and Confederate forces. Ulysses S. Grant bought his cigars and newspaper at the "corner store" here. Military headquarters were established in the town, and officers lodged in the hotels and dined and entertained in downtown Culpeper.

Though Culpeper's military history is overshadowed by its role in the War Between the States, its sons have fought in all wars that America has engaged in. She proudly sent sons, husbands, and fathers to World War I, the many theaters of World War II, the fields of Korea and Vietnam, and the modern wars of Desert Storm and Iraq.

Most of the buildings in today's downtown were built following the Civil War. The town is characterized by High Victorian and Italianate styles of architecture and remains the center of government and the county's viable commercial district.

Downtown Culpeper has experienced success and depression. The town renewed itself following the Civil War only to suffer through the Depression era. She rallied again, only to succumb like most of small-town America to the strip malls and large commercial development that took people out of the downtown. However, true to the spirit of the people of Culpeper, a determined effort was made to rid the town of boarded-up storefronts and the atmosphere of dilapidation. The town government, merchants, property owners, and the community collaborated to bring vitality back to the downtown center. In 1988, Culpeper joined the Virginia Main Street Program, pledging to safeguard landmarks while moving toward commercial renewal.

One

BUSINESS, COMMERCE, AND GOVERNMENT

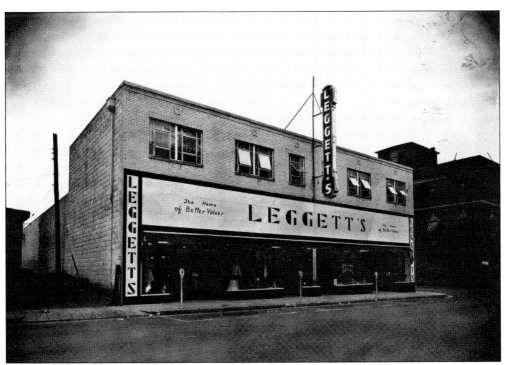

Legget's Building, on Main Street, is pictured on August 21, 1942. Legget's Department Store is now the Culpeper Post Office. (Photograph courtesy of the Culpeper Museum of History.)

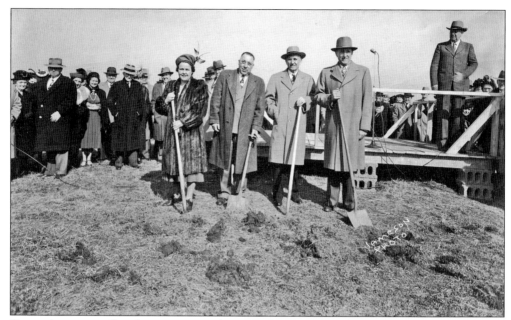

Pictured is a groundbreaking ceremony for a new business in Culpeper. Several new businesses opened their doors in Culpeper in the late 1940s. (Photograph courtesy of the Culpeper Museum of History.)

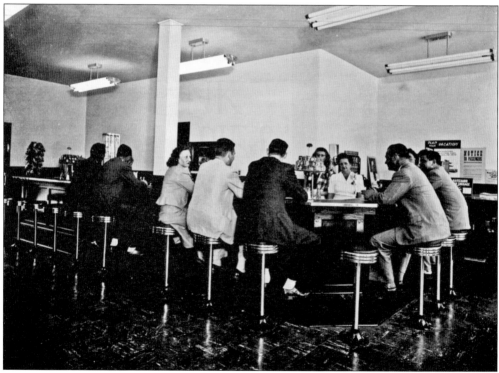

Lunch counters were popular in local drugstores, such as this one in Gayheardts in the late 1940s. Marshall Gayheardt bought the Booton building in 1953. Gayheardts Drug Store occupied the ground floor until 2002. (Photograph courtesy of the Culpeper Museum of History.)

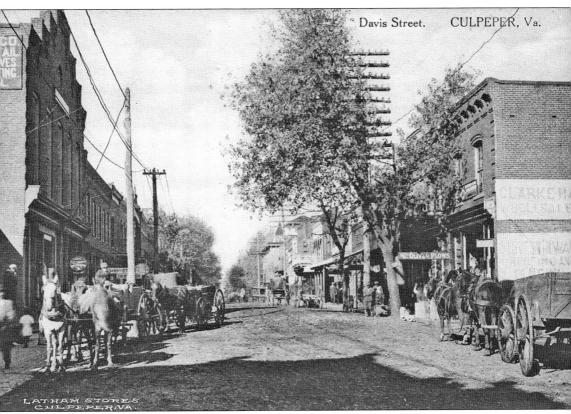

Latham Stores produced this Davis Street postcard. Note the Clark Hardware sign. Celebrating its 100th anniversary in 2006, it is still a destination business in downtown Culpeper. Latham 5-and-10¢ Store on Davis Street was truly a dime store, with nothing priced over 10¢. Alan's Studio now occupies the building. (Photograph courtesy of the Culpeper Museum of History.)

Culpeper electric workers appear to be repairing wiring. The first electric lights were turned on in Culpeper in 1903. Power was furnished by the Culpeper Light and Ice Company. Most rural residences did not get electricity until the late 1930s or early 1940s. Its possible these men are wiring a home for its first electric lights. (Photograph courtesy of the Culpeper Museum of History.)

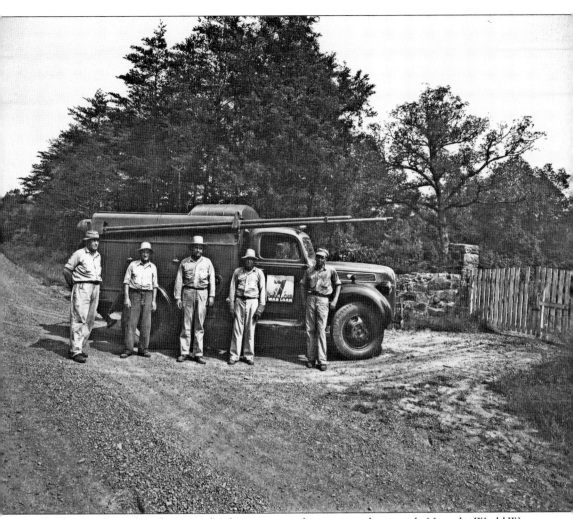

The electricians and truck seem to be the same as in the previous photograph. Note the World War II slogan on the side of the truck. (Photograph courtesy of the Culpeper Museum of History.)

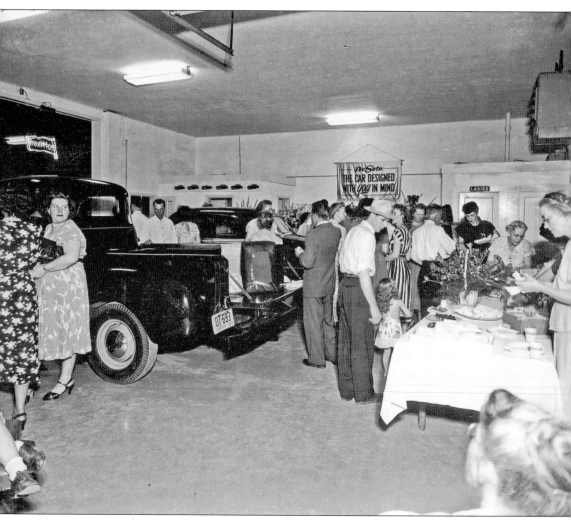

A reception at a local car dealership was put on to introduce the new car models to people in Culpeper. Note the Desoto banner on the far wall. The first dealerships were opened in Culpeper in 1912. The Culpeper Motor Company and a Ford dealership opened in the same year. (Photograph courtesy of the Culpeper Museum of History.)

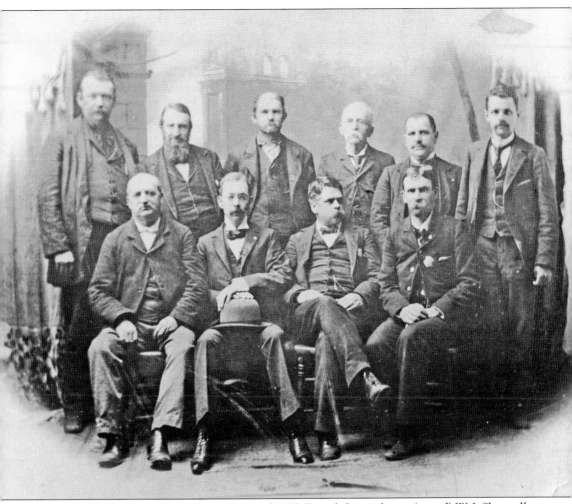

Pictured is the Culpeper Town Council around 1895. From left to right are (seated) W. J. Shotwell, recorder, assessor, and treasurer; Charles M. Waite, mayor; John L. Jeffries, town attorney; and M. B. Hansborough, town sergeant; (standing) David Bailey, Dr. R. S. Lewis, William Littleton Rosson, Abner M. Allan, Sam Diener, and Robert B. Booton. (Photograph courtesy of the Culpeper Museum of History.)

This postcard is a photograph of the Culpeper County Court House. (Photograph courtesy of the Culpeper Museum of History.)

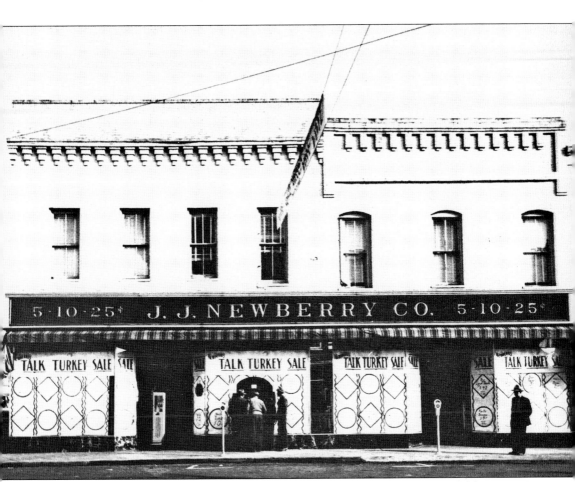

J. J. Newberry Company hosts a Talk Turkey Sale. The department store was one of downtown's anchors in the 1950s and 1960s. (Photograph courtesy of the Culpeper Museum of History.)

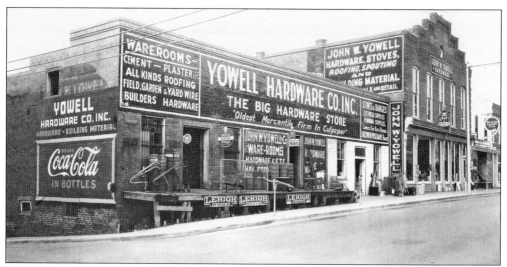

Yowell Hardware was founded in 1900 by John W. Yowell Sr. and Mr. Covington. Covington was bought out in 1906. John Yowell Jr. ran the store after World War II until selling the business in the 1970s. Yowell Hardware store is located at Davis and East Streets. (Photograph courtesy of the Culpeper Museum of History.)

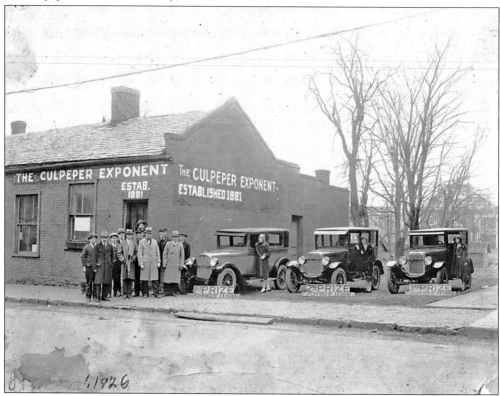

Culpeper Star Exponent Building is pictured on January 1, 1926. The paper was known as the *Culponent* and was the result of a merger in 1953 between the *Exponent*, founded in 1889 by Angus McDonald Green, and the *Virginia Star*. (Photograph courtesy of the Culpeper Museum of History.)

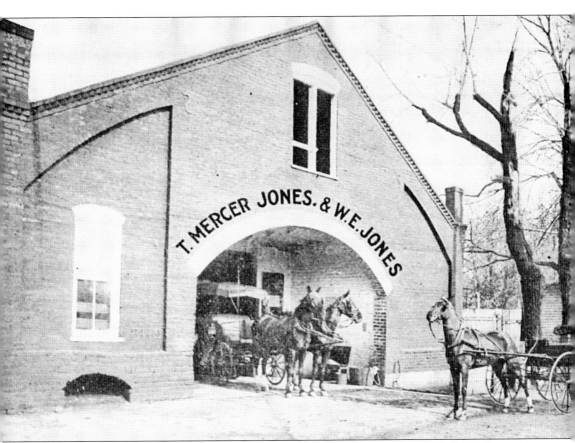

Jones Livery Stable, pictured around 1914, stood on Commerce Street, directly behind what used to be the Anne Wingfield School. The Jones brothers advertised high-class livery, feed, and sales stables. Drivers for hire and rubber tires were two specialties of the shop. In the 1914 advertisement, they reportedly pay prompt attention to funerals, weddings, and all other functions. (Photograph courtesy of the Culpeper Museum of History.)

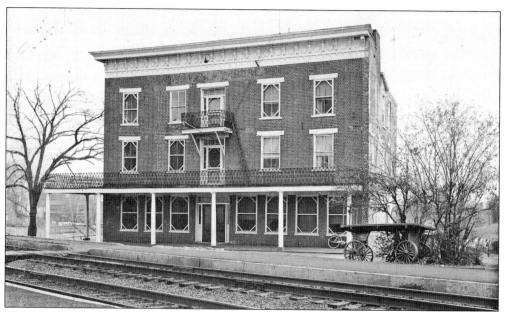

Waverly Hotel was well known for its good food and was a popular stop during the fashionable years of rail travel. (Photograph courtesy of the Culpeper Museum of History.)

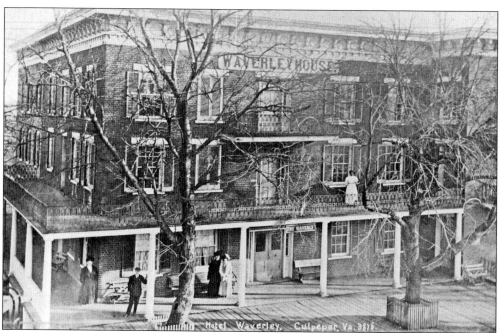

Waverly Hotel, pictured at the beginning of the 20th century, was located at the end of East Davis Street across the railroad tracks. It was built by E. B. Hill. From 1856 to 1859, the Female Institute, operated by J. Walker George, occupied the building. The two women standing together are Mrs. J. M. Fraley and her daughter, Lela. Mrs. Fraley ran the hotel. This building was torn down in the early 1970s. (Photograph courtesy of the J. R. Guinn Collection at the Culpeper Museum of History.)

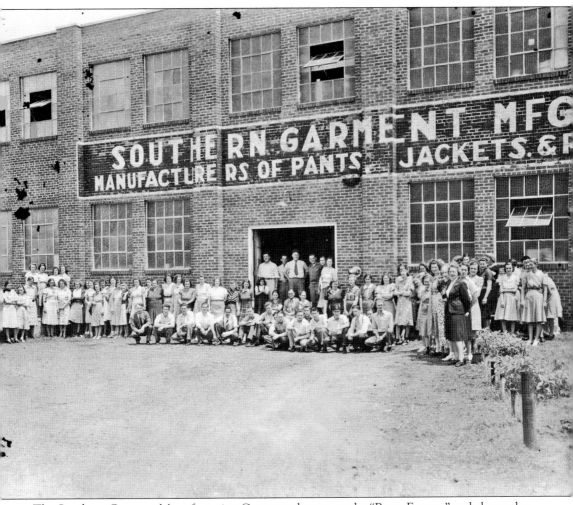

The Southern Garment Manufacturing Company, known as the "Pants Factory" and also as the sewing factory, employed women in the 1940s. The structure is currently an apartment building. (Photograph courtesy of the Culpeper Museum of History.)

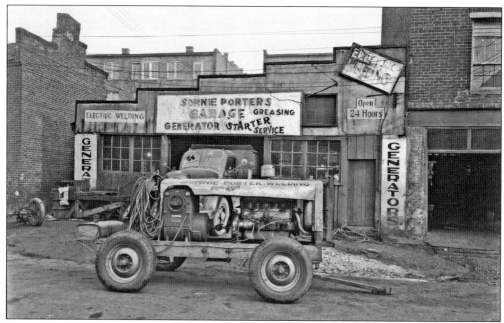

Sonnie Porters Garage was a welding shop with the motto "We mend anything except a broken heart," according to Donnie Johnson's book *Culpeper, A 20th Century History.* (Photograph courtesy of the Culpeper Museum of History.)

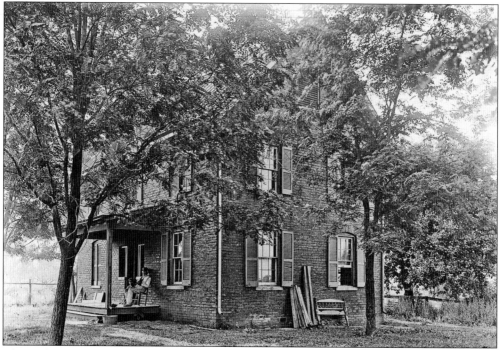

This early-1900s photograph shows Culpeper County Almshouse, known as "Poor Town," which consisted of a barn and several outbuildings. The large two-story brick structure housed the town's inmates, and a stone house was home to the superintendent and his family. Poor Town was closed in 1927. (Photograph courtesy of the Culpeper Museum of History.)

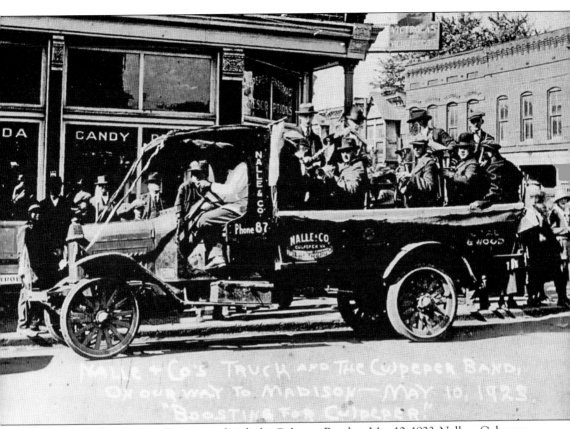

A Nalle and Company truck is pictured with the Culpeper Band on May 10, 1923. Nalle, a Culpeper native, designed, built, and equipped his foundry and machine shops. The machine shop, foundry, and planing mill annex, all steam operated, were located on the Southern Railway. (Photograph courtesy of the J. R. Guinn Collection at the Culpeper Museum of History.)

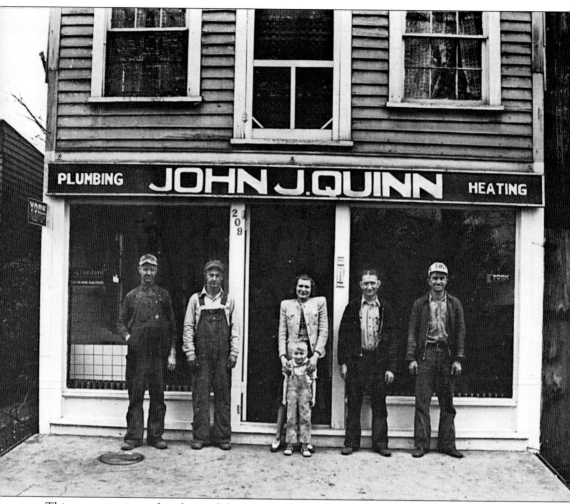

This group is pictured in front of the John J. Quinn Store in the 1940s. From left to right are R. J. Davis, Raymond Peyton, Mary Quinn and son John Jr, J. J. "Jack" Quinn, and John Cook. (Photograph courtesy of the Culpeper Museum of History.)

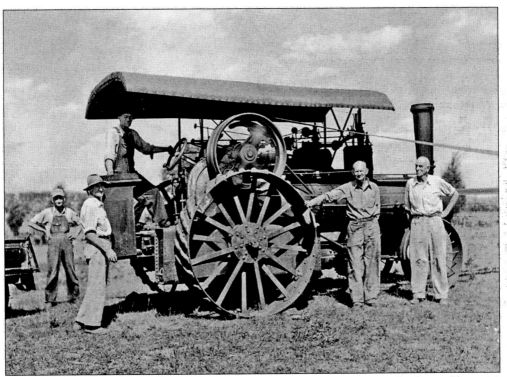

Pictured in August 1954 are, from left to right, Bert Yea, Haywood Dodson, Cletus H. Somers, Carroll W. Thornhill, and Oscar R. Clarke. (Photograph courtesy of the Culpeper Museum of History.)

This early photograph of Modern Steam Laundry was taken in 1909. The laundry was built in 1906 by O. P. Gazier and operated by him and R. H. Briggs. It was located at the rear of the Culpeper Presbyterian Church. The addition to the church was built on this site. (Photograph courtesy of the Culpeper Museum of History.)

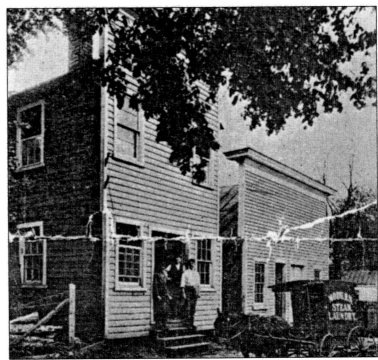

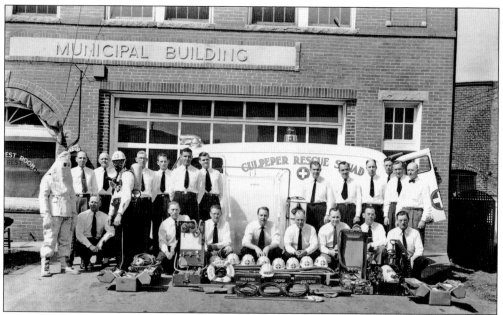

This is an early photograph of the Culpeper Rescue Squad in the 1940s or 1950s. (Photograph courtesy of the Culpeper Museum of History.)

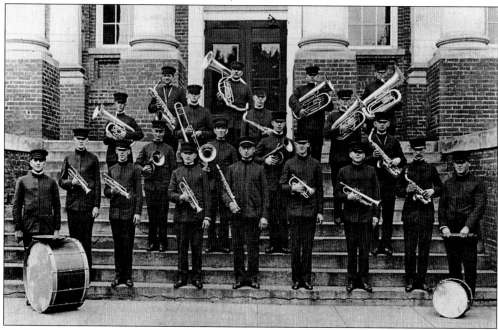

The Culpeper Municipal Band is shown here in the 1920s. From left to right are (first row) Lewis "Shank" Morris, W. D. Dinnie Reames, Ernest Almond, George Becknell, Frank Becknell (director), J. J. "Jack" Quinn, Frank Maquire, Earlton Curtis, and Richard "Dick" Pierce; (second row) Robert C. Bruce, Wilton Finks, Harry Yea, and Robert Mills; (third row) H. M. "Billy" Hawkins, Norman Compton, Louis Curtis, and Rusell Rumsey; (fourth row) George Shaw, David Douglas, Oscar "Daddy" Coates, and Willie B. "Tarzan" Rosson. (Photograph courtesy of the Culpeper Museum of History.)

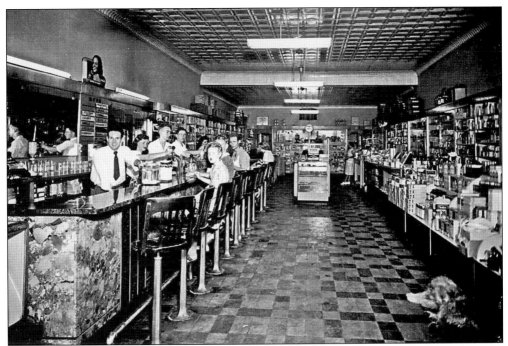

The interior of Gayheardts Drug Store is pictured in the 1940s. The drugstore was located on Davis Street and was originally Macoy's Drug Store. (Photograph courtesy of the Culpeper Museum of History.)

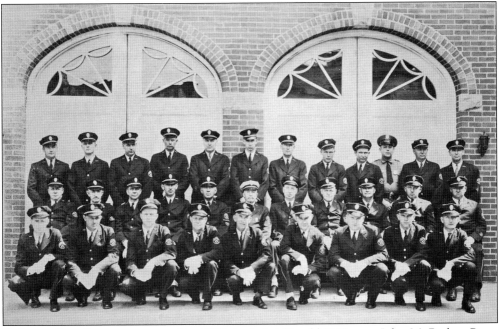

Culpeper Fire Company, pictured in 1930, included Harold T. Brown, John M. Barber, Percy Johnson, Bill Harlow, George Lillard, Edgar O. Willis, J. William Nicholson, Arthur Carroll, Jack Quinn, and others. (Photograph courtesy of the J. R. Guinn Collection at the Culpeper Museum of History.)

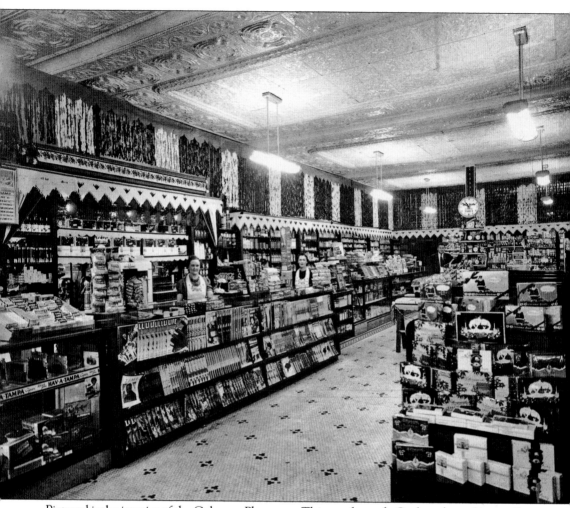

Pictured is the interior of the Culpeper Pharmacy. This was formerly Gayheardts and is now Frost Café. From left to right are Lucille Inskeep Morris, Rebecca Kilby Wood, and Dr. G. F. Hendley, the owner. (Photograph courtesy of the Culpeper Museum of History.)

Elmo Kilby's Blacksmith Shop at Clarkson is pictured with Elmo Kilby shoeing a horse, and Sam Clatterbuck holding the animal. Next to him is Rev. E. H. Grasty, an African American minister and educator. The man standing closest in foreground is Anselum Marion "Bragg" Kilby, Elmo Kilby's father. (Photograph courtesy of Mrs. Donald L. Kilby and the Culpeper Museum of History.)

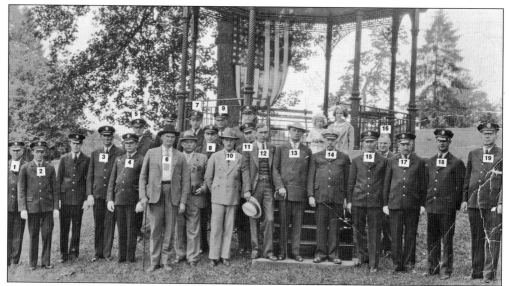

Culpeper Fire Department conducts Memorial Day services at the Culpeper National Cemetery on May 30, 1932. Members of the fire department shown in the photograph are, numbered from left to right, W. B. Rosson, John M. Barber, William "Bill" Legg, Dillard Petty, Murphy Hoffman, Maj. John R. Kerrick, Mahlon McAllister, Ward Bushong, R. T. "Bob" Estes, cemetery superintendant Boston ?, Letcher Longerbeam, C. Everett Reams (commander of the American Legion), Gen. William "Billy" Mitchell, J. William Swan (fire chief), George R. Lillard, Rufus G. Roberts (publisher of the *Virginia Star* and later Culpeper's postmaster), J. A. "Jim" Swan, Edgar O. Willis Jr., and L. Cave Major (captain of the fire company). (Photograph courtesy of the Culpeper Museum of History.)

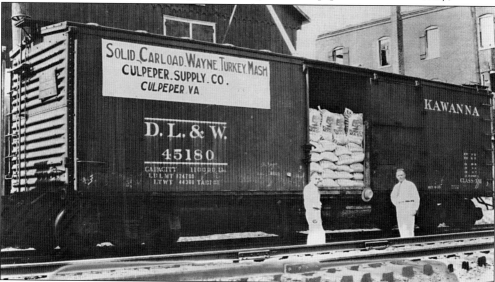

This is the first carload of turkey mash ever shipped in the United States. In 1930, the Wayne Feed Company of Buffalo, New York, shipped the first carload of feed made especially for turkeys to Culpeper Supply Company, owned by J. Walton Loving. Walton Loving is at left, and H. K. Hagerman, salesman for Wayne Feed, is at right. Loving and Hagerman had a part in putting together the formula for the feed. (Photograph courtesy of Walton Loving and the Culpeper Museum of History.)

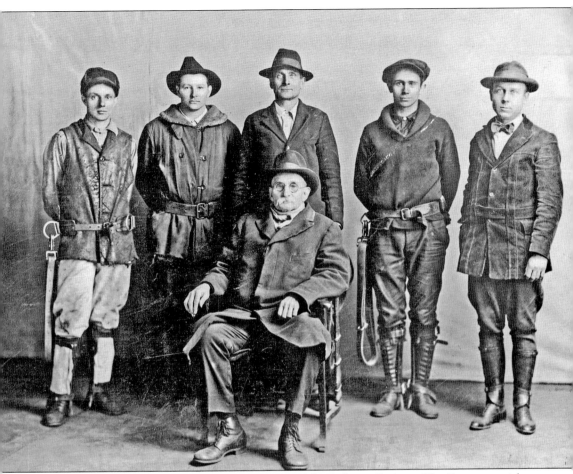

This 1924 photograph shows owner George F. Major, of the Culpeper Light and Ice Company, with his staff of electricians. The company was founded in 1904 by Major and Dr. Orville Nalle. The company was located on east side of the railroad tracks near the National Cemetery. (Photograph courtesy of the Culpeper Museum of History.)

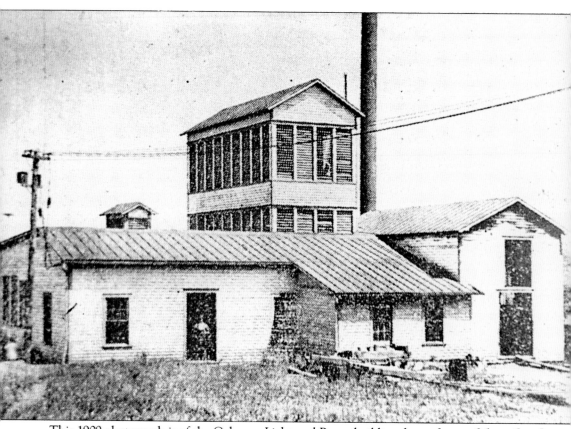

This 1909 photograph is of the Culpeper Light and Power building, located east of the railroad tracks. The town of Culpeper had telephone service furnished by the Culpeper Telephone Company beginning in 1901 and electricity provided by the Culpeper Light and Ice Company beginning in 1903, the only electric lights between Alexandria and Charlottesville. The electric plant, except for manufacturing ice, only provided lighting. The plant operated from sundown to dawn to light homes and businesses. (Photograph courtesy of the Culpeper Museum of History.)

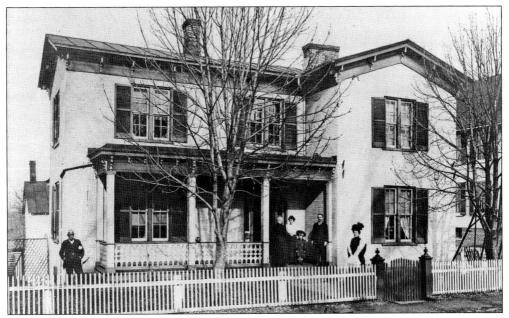

The Allan house, at 306 East Piedmont Street, was built in 1871. The house was constructed of old brick salvaged from the second courthouse, which was torn down in 1871. (Photograph courtesy of the Culpeper Museum of History.)

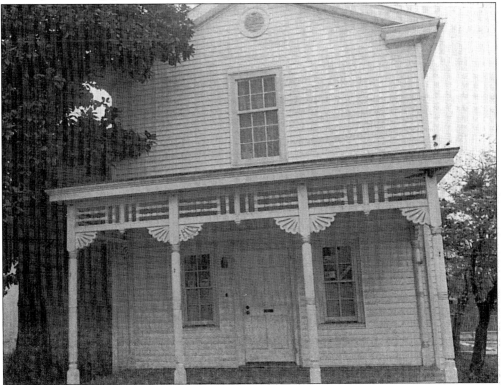

Pres. Chester A. Arthur's wife, Eleanor Herndon, is believed to have been born at the Norris house, located at 402 South Main Street. (Photograph courtesy of the Culpeper Museum of History.)

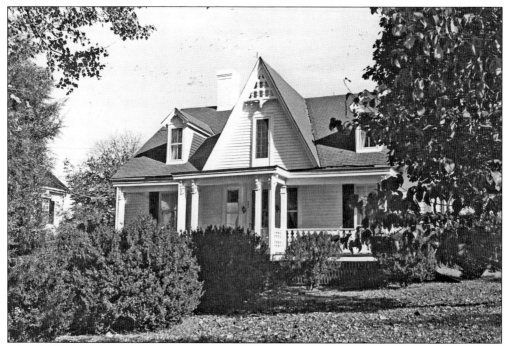

The Chelf House, located on East Street, was built by C. B. Payne, who served as clerk of the court for Culpeper. The house was built around 1852, just prior to the War Between the States, on land that once belonged to Capt. Thomas Hill, father of Confederate general A. P. Hill. (Photograph courtesy of the Culpeper Museum of History.)

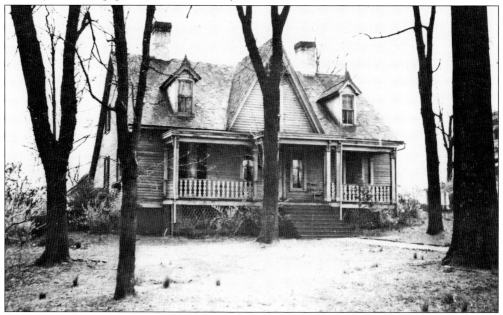

This earlier photograph of the Chelf House shows an example of the Romantic-era Gothic Revival style. The house was used as Union headquarters during the war. The family lived upstairs while Union officers occupied the downstairs. (Photograph courtesy of the Culpeper Museum of History.)

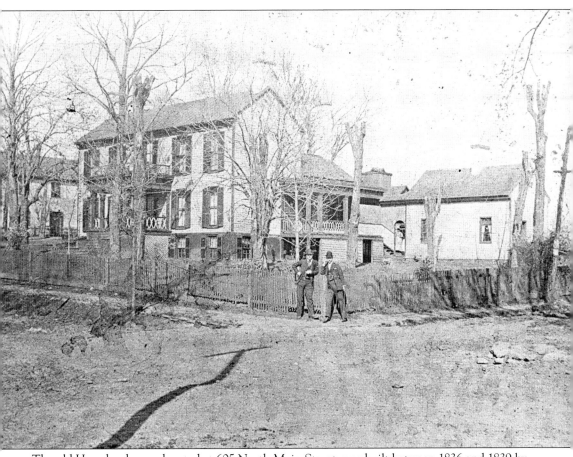

The old Herndon house, located at 605 North Main Street, was built between 1836 and 1839 by Brodie S. Herndon. The house also lays claim to being the birthplace of Eleanor Herndon, later the wife of Chester A. Arthur. The Herndons lived in the Norris house on South Main Street while this home was being built. (Photograph courtesy of the Culpeper Museum of History.)

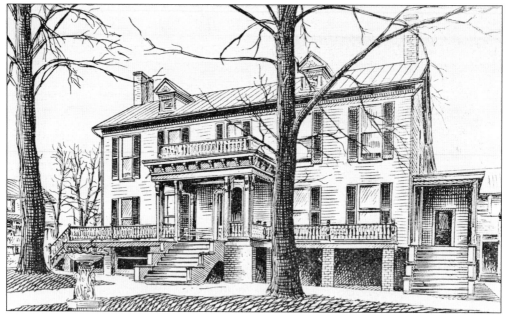

The Herndon Smith House is shown in a pen-and-ink drawing. The Greek Revival–style home was the first in Culpeper to have porcelain bathtubs. (Photograph courtesy of the Culpeper Museum of History.)

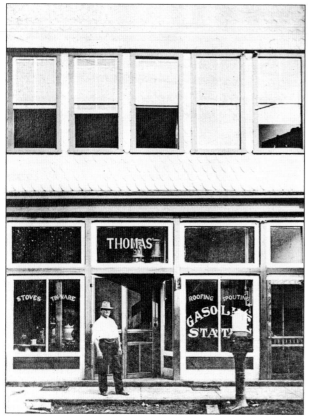

This photograph of the Thomas Gas Station was taken in 1915. This building was located on East Davis Street near the depot. The gasoline pump was the first in Culpeper. (Photograph courtesy of the Culpeper Museum of History.)

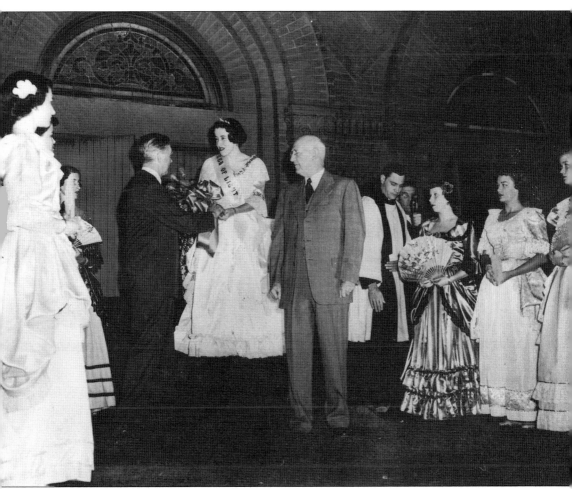

Skyglow, on November 13, 1953, was a community-wide celebration of the lighting of the first fluorescent lights south of the Mason-Dixon Line. From left to right are Lois Aylor, Princess Madison; May Massie Lea, Princess Rappahannock; Jacquelin Bragg, maid of honor; T. I. Martin, general chairman of the Skyglow committee; Ida Sparks Smith, Queen Skyglow; Mayor L. Frank Smith; and Rev. David Lewis. The others are unidentified.

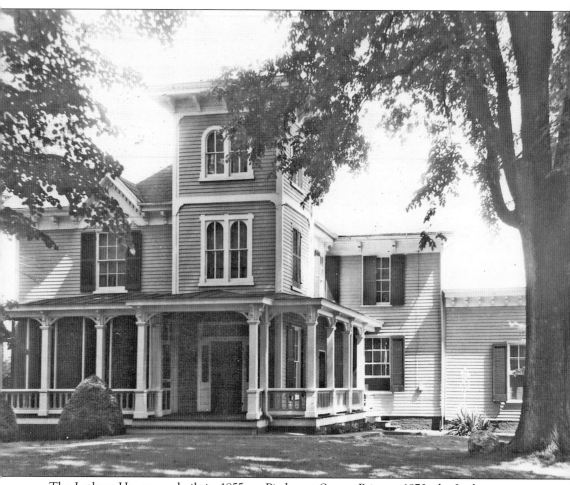

The Latham House was built in 1855 on Piedmont Street. Prior to 1870, the Latham property included all of the land on the north side of Piedmont Street bordered by Mountain Run Creek. The house no longer stands. (Photograph courtesy of the Culpeper Museum of History.)

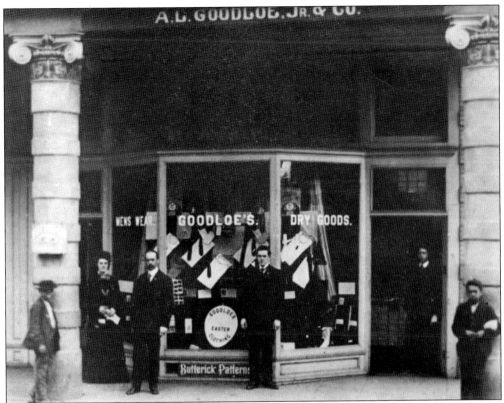

Goodloe's Dry Goods Store, as seen in this early 1900s photograph, was located in the Masonic Building at the corner of Davis and East Streets. Pictured from left to right are Emma Hall Truett, Archie Goodloe, and Mercer Jennings. The man in the door and the two boys are unidentified. (Photograph courtesy of the Culpeper Museum of History.)

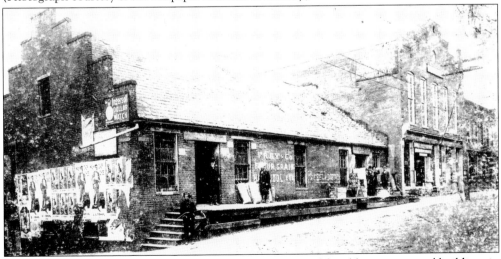

Fray and Company was located on east Davis Street in one of the oldest commercial buildings in Culpeper. Built approximately 1835, the building housed a stable, a tobacco warehouse, and was used as a jail by both the Union and Confederate armies. (Photograph courtesy of the Culpeper Museum of History.)

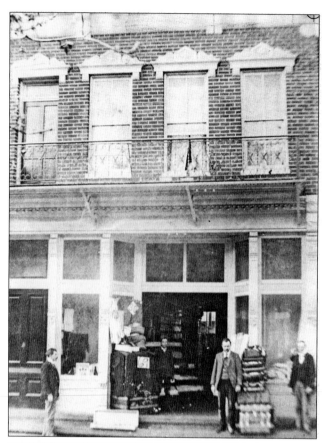

The General Merchandise store is shown in this 1903 photograph. The store was owned by Mr. Briscoe and was located on East Davis Street. Pictured from left to right are Poesy Jasper, unidentified man standing in the store, Mr. Briscoe, and John W. Shotwell. (Photograph courtesy of the Culpeper Museum of History.)

This view of Main Street looking south was taken in 1910. Pictured are, from left to right, the Groves Home, Bailey House, Morrise House, and Forbes Row. On the left is the Groves home. Notice the muddy street— Culpeper's first macadam streets were built in 1912. (Photograph courtesy of the J. R. Guinn Collection at the Culpeper Museum of History.)

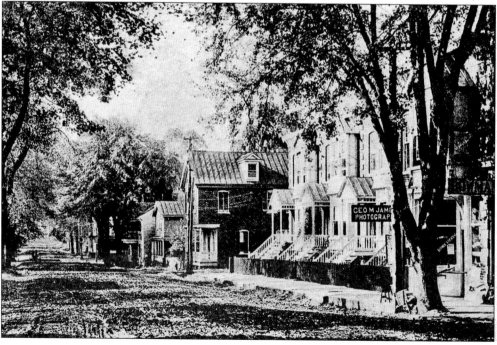

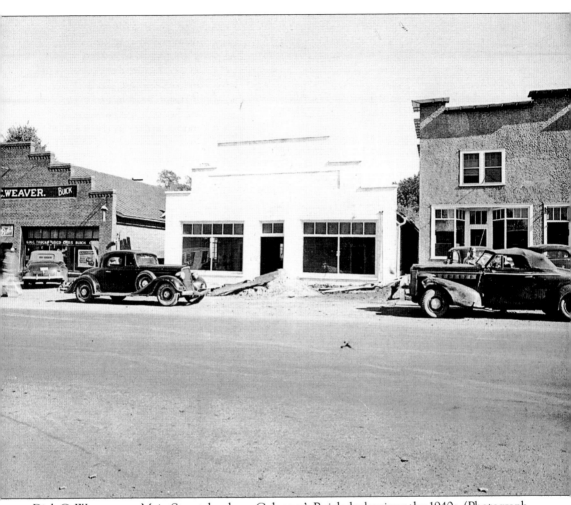

Dick C. Weavers, on Main Street, has been Culpeper's Buick dealer since the 1940s. (Photograph courtesy of the Culpeper Museum of History.)

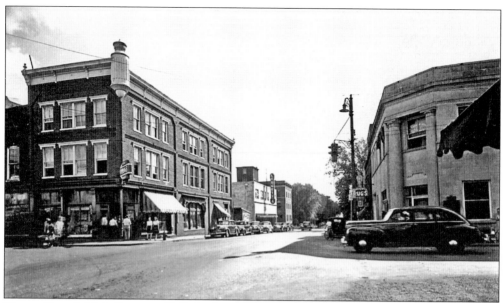

Pictured here is Main Street in 1949. Gayheardt Drug Store is seen on the left. The building now houses Frost Café and two floors of apartments. (Photograph courtesy of the Culpeper Museum of History.)

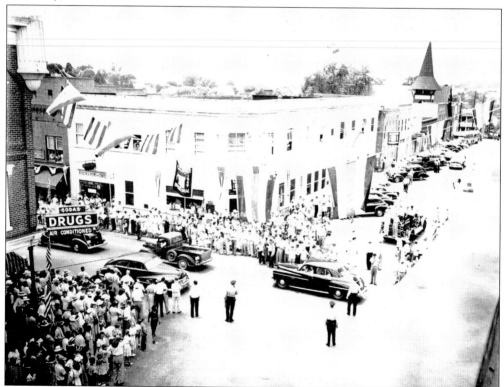

Main and Davis Streets, c. 1949, is the site of Culpeper's centennial celebration. The steeple of the old Methodist church is seen in the background. It was later destroyed. (Photograph courtesy of the Culpeper Museum of History.)

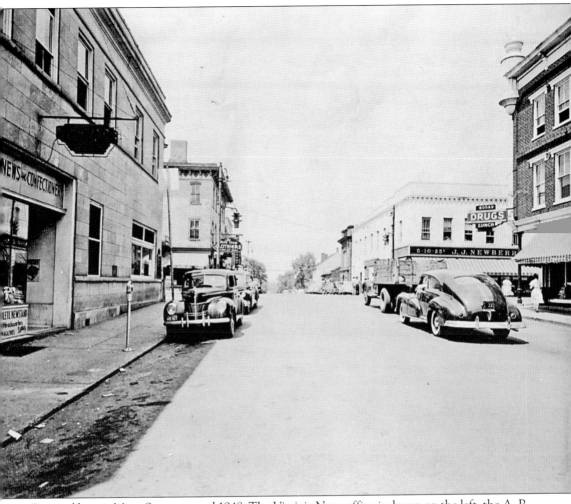

Pictured here is Main Street around 1948. The *Virginia News* office is shown on the left, the A. P. Hill building on the next corner, and Gayheardt Drug Store on the right. (Photograph courtesy of the Culpeper Museum of History.)

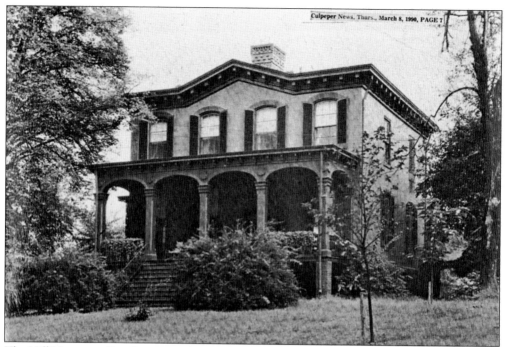

The Hill House, on East Street, was built around 1855. It was the home of Maj. E. B. Hill, brother of Gen. A. P. Hill, during the War Between the States. During the war, the house was used as both a Confederate hospital and as Union headquarters. (Photograph courtesy of the Culpeper Museum of History.)

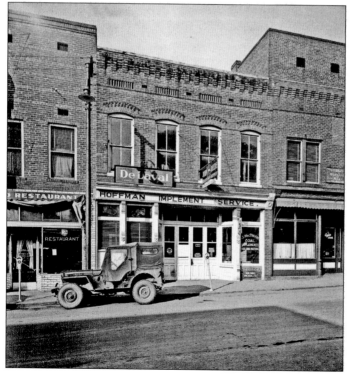

Pictured is the first block of South Main Street in 1947. From left to right are the Greenland Restaurant, Hoffman Implement Service, and the *Virginia Star*. (Photograph courtesy of the Culpeper Museum of History.)

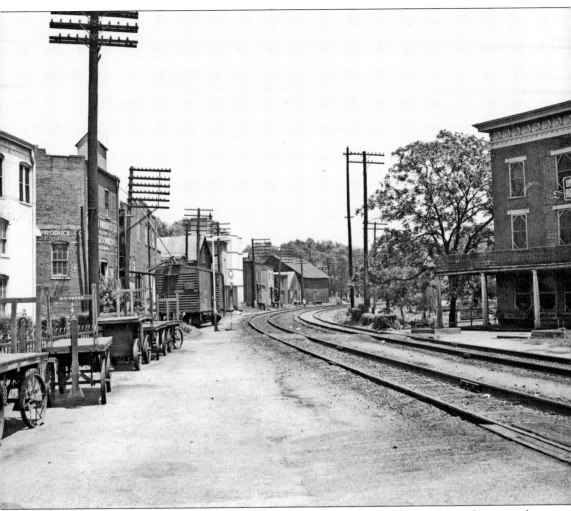

This Southern Railroad scene was taken in the 1940s. Now the Norfolk Southern, the original train to arrive in Culpeper was the Orange and Alexandria Railroad. There was a turntable located in Culpeper about the time of this photograph. (Photograph courtesy of the Culpeper Museum of History.)

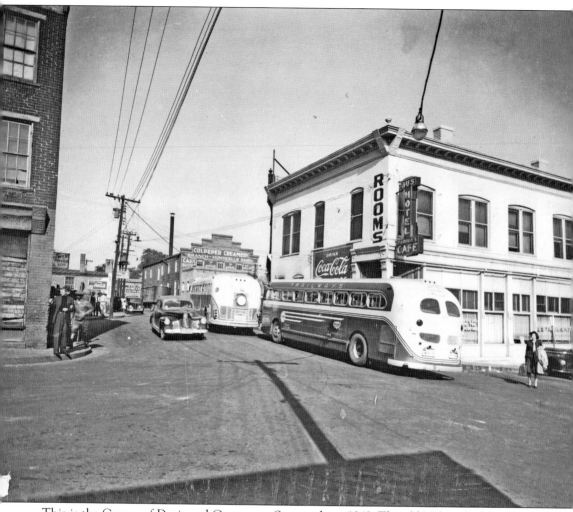

This is the Corner of Davis and Commerce Streets about 1949. The old Nelson building is on the left, Jimmy "the Greek" Kreticos's café and bus station is on the right, and the old Culpeper Creamery is in the far background. (Photograph courtesy of the Culpeper Museum of History.)

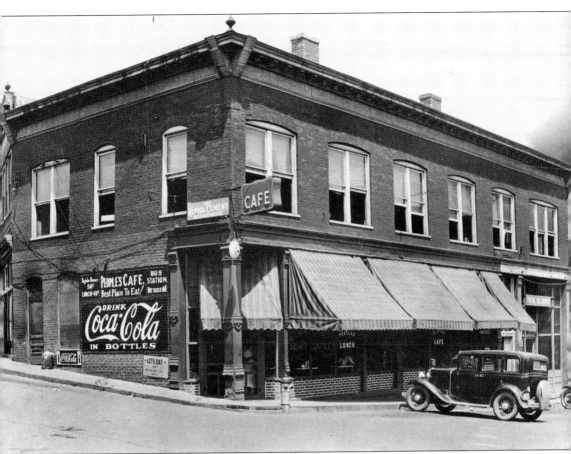

The Peoples Café served as the Culpeper Bus Stop in the 1940s. The café was not only popular with travelers but was also a favorite place for lunch with local Culpeper residents. (Photograph courtesy of the Culpeper Museum of History.)

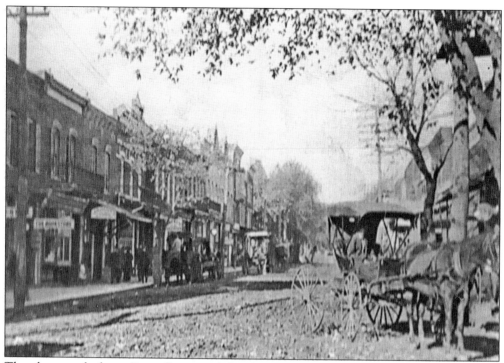

The photograph shows Davis Street and the downtown business district in the early 1900s. (Photograph courtesy of the Culpeper Museum of History.)

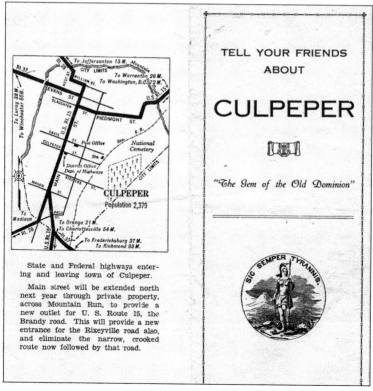

State and Federal highways entering and leaving town of Culpeper.

Main street will be extended north next year through private property, across Mountain Run, to provide a new outlet for U. S. Route 15, the Brandy road. This will provide a new entrance for the Rixeyville road also, and eliminate the narrow, crooked route now followed by that road.

The chamber of commerce produced this promotional pamphlet with the slogan "The Gem of the Old Dominion." (Pamphlet courtesy of the Culpeper Museum of History.)

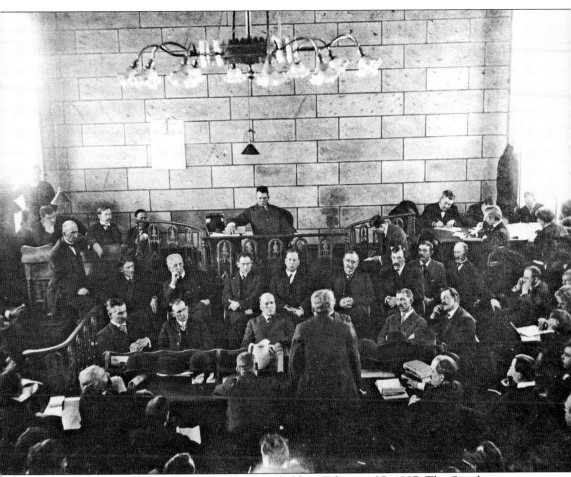

The trial of James and Phillip J. Strother was held on February 25, 1907. The Strothers were being tried for killing Will F. Bywaters on the night of December 15, 1906. The jury was from Shenandoah County. This photograph shows John L. Jeffries making the opening statement in the trial. (Photograph courtesy of the Culpeper Museum of History.)

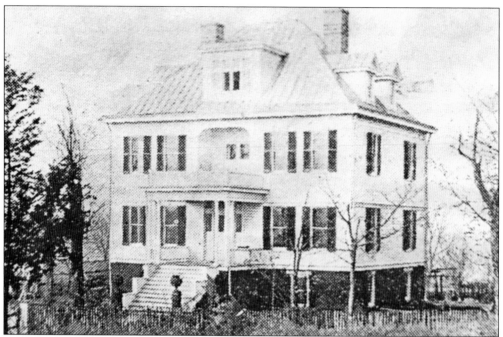

The Sanatorium, Culpeper's first hospital, was opened in 1909 by Dr. C. S. Cowie. (Photograph courtesy of the Culpeper Museum of History.)

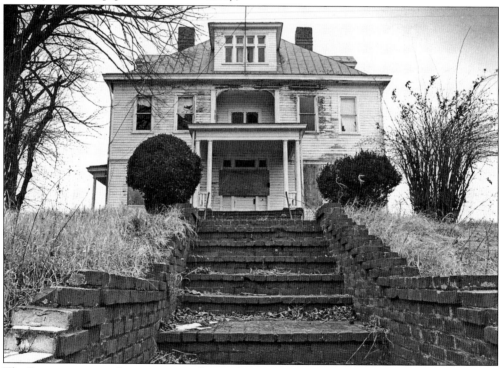

The Sanatorium ceased operations as a hospital in 1928 and became Culpeper's first nursing home. The nursing home was operated by Mrs. J. Broadus Stringfellow. The old building was torn down in 1987. (Photograph courtesy of the Culpeper Museum of History.)

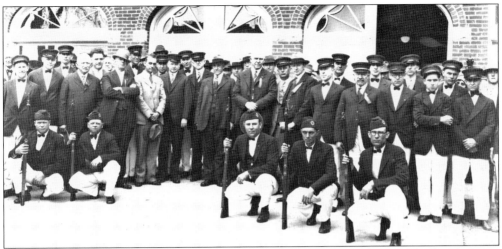

The Town of Culpeper dedicated a new municipal building in April 1928. The building was constructed as a fire department, town office, library, and banquet hall. Pictured are, from left to right (squatting) Dillard Petty, Bill Smith, Charlie Smith, John Barber, and Jack Colvin; (standing) George Lillard, Hub Richards, Jesse Yowell, Mayor Sam Browning, Verne Healy, town treasurer Zeph George, L. A. Rhoades Sr., Murphy Hoffman, unidentified, Ray Hudson, unidentified, Byrd Leavell, William J. Smith, town manager Robert "Bob" Huffman, John W. Yowell, William D. Cannon, R. T. Estes, fire chief J. William Swan, Ward Bushong, Ronnie Wythe, Everett Reams, Henry Thompson, Julian Brown, Katherine Reaguer, Bill Harlow, and Bruce Corbin. (Photograph courtesy of the Culpeper Museum of History.)

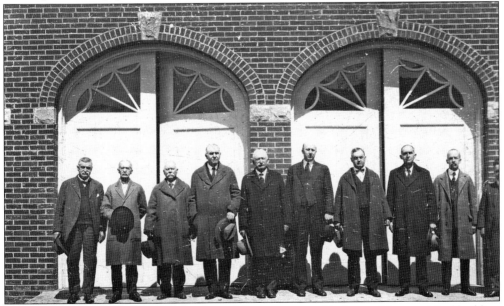

Mayor S. R. Browning poses with members of the town council in front of the municipal building in 1928. Pictured are, from left to right, treasurer J. T. George; Atwill Somerville, town council member; E. A. Walter, town council member; Byrd Leavell, town council member; Mayor S. R. Browning; town attorney E. E. Johnson; John S. Covington, town council member; Charles H. Still; recorder Fred Sturdguis; and W. Bosomaur Clark, town council member. (Photograph courtesy of the Culpeper Museum of History.)

A

Culpeper	136-J	Abbott, I. C., Res.	B
Culpeper	136-H	Abbott, I. C. Jr., Res.	B
Culpeper	136-R	Albert, J. W., Res.	B
Culpeper	296-Y	Albright, J. C., Res.	Cul
Culpeper	283-X	Allan, Miss Blanche H., Res.	Cul
Culpeper	108-N	Allen, I. J., Res.	Rixeyville, R.
Culpeper	205-B	Allen, S. T., Res.	Cul
Culpeper	219-A	Allen, S. T. (Belvedere)	Cul
Culpeper	128-M	Allison, T. L., Res.	Richard
Orange	82	American Ry. Express Office	O
Orange	101-B	Amos, G. A., Res.	Orange R.
Orange	121-Y	Amos, Harry C., Res.	Woodberry F
Orange	101-P	Amos, J. R., Res.	Locust
Orange	101-O	Amos, R. L., Res.	Orange R.
Culpeper	149-V	Anderson, Mrs. E. R., Res.	Culpeper R.
Orange	68-Y	Anderson, Mrs. Luther, Res.	O
Orange	62-AZ	Andrews, Dr. J. S., Res.	Orange R.
Culpeper	60-X	Apperson, B. M., Res.	Cul
Culpeper	113-N	Apperson, J. M., Res.	Culpeper R.
Culpeper	252-X	Apperson, R. M., Res.	Cul
Culpeper	111-L	Apperson, W. W., Res.	Culpeper R.
Culpeper	121-D	Appleton Farm, Res.	Elk
Orange	107-D	Armentrout, E. W., Res.	Ra
Culpeper	255-A	Armstrong, A. J., Res.	Cul
Sperryville	9-N	Armstrong, Mrs Ella B., Res.	Woo
Culpeper	262-Y	Armstrong, Miss Gertrude, Res.	Cul
Culpeper	126-N	Armstrong, M. B., Res.	Rixeyville R.
Culpeper	245-Y	Ashby, Mrs. Norman, Res.	Cul
Orange	18	Ashton, R. L., Mer.	O
Orange	44-A	Ashton, R. L., Res.	O
Sperryville	16-C	Atkins, J. M., Mer.	Sperr
Orange	130-I	Aylor, H. I., Res.	Oak
Culpeper	124-C	Aylor, James M., Res.	N
Madison	8-A	Aylor, J. N. (Pay Sta.), Mer.	F
Culpeper	124-H	Aylor, J. T., Res.	N
Culpeper	124-V	Aylor, J. W., Mer.	N
Culpeper	131-C	Aylor, Lucian, Res.	Winston R.
Madison	13-S	Aylor, R. C., Res.	Bright
Orange	129-D	Aylor, Sim, Res.	Mitchells R.
Orange	103-J	Aylor, T. B., Res.	Rapidan R.
Orange	130-T	Aylor, Mrs. T. F., Res.	Winston R.

B

Culpeper	255-Y	Bailey, E. D., Res.	Cul
Orange	169	Bailey, Mrs. J. S., Res.	O
Orange	84-B	Bailey, N. C., Res.	O

This early telephone book shows how much today's telephone numbers have changed. Culpeper's first telephone book was published in 1904 with 40 pages. The Culpeper Telephone Company was organized in 1901 and reorganized in 1909. By 1914, the company had 1,100 subscribers and exchange stations at Culpeper, Orange, Madison, and Rappahannock Counties. The executive offices were located on East Street in downtown Culpeper. (Book courtesy of the Culpeper Museum of History.)

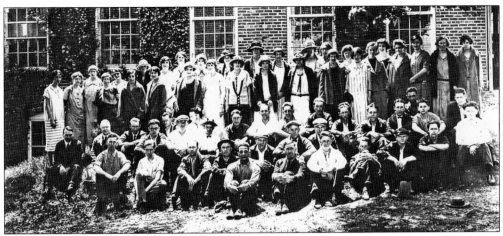

In 1926, the Culpeper Silk Mill was a leading employer in Culpeper County. Pictured outside of the mill are, from left to right, (first row) Eddie Walters, Col. Walter Dowell, Gid Brown, W. L. Dodson, Valley Smith, Fisher Deal, and Lee Brown (in white shirt); (second row) Alfred Meade, ? Thompson, Dean Anthony, Jesse Anthony, David Gardner, Cecil Kivett, and Roy McClung; (third row) T. R. Connlain (manager), A. H. Eastmond (owner), Bill Bailey, Leon Dodson, Red Murphy, Charlie Walker, Eugene Brookman, Dick Bache, John T. Dodson, William Collins, Steve Schnable, Harry Hitt, and Marvin Hitt; (fourth row) Grace Omohundro (secretary), Bessie Yancey, Ada Sowers, Lena Willard, Virginia Fincham (Stultz), Helen Elliott, Annie Mae Gore (Finks), Sadie Yowell, Virginia Burke (Fassett), Elizabeth Gore, Eva Yowell (Brown), Lelia Smith (Courtney), Bessie Courtney (Kivett), Virginia Settle (McGee), Earl Spicer, Polly Burke, Hattie Spicer (Carder), Saville Deal (Doggett), Ethel Spicer (Smith), Mary J. Dobson, Gabe Burke (Bache), Rosa Davis, Susie Myers, Mary B. Dodson, Gertrude Aylor, Hattie Hillman, Lizzie Stringfellow (Hoffman), Mattie Hensley (Meade), and Grace Yowell (Hart). The silk mill was established in Culpeper in 1913 to manufacture broad silk with James Rigby Jr. as president, J. L. Fray and Charles Forbes as vice presidents, A. L. Goodloe as treasurer, and L. Frank Smith as secretary. (Photograph courtesy of the Culpeper Museum of History.)

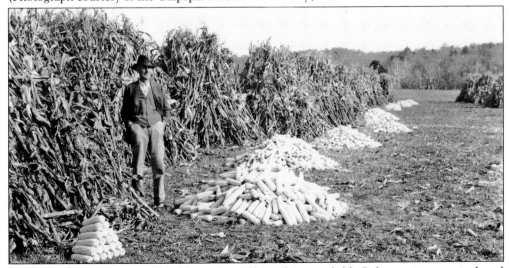

H. D. Crigler Sr. is pictured in November 1938 in his cornfield. Culpeper is an agricultural community known for its corn, wheat, and, at the time of this photograph, dairy business. (Photograph courtesy of the Culpeper Museum of History.)

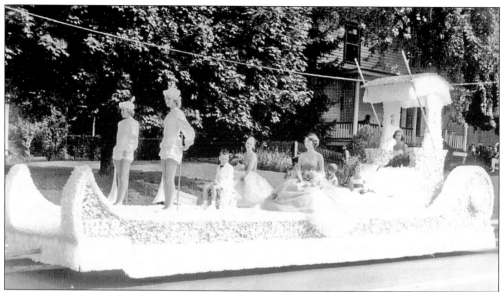

The parade float was used in honor of the 1959 Town of Culpeper bicentennial. The town, originally known as Fairfax, was founded in 1759. (Photograph courtesy of the Culpeper Museum of History.)

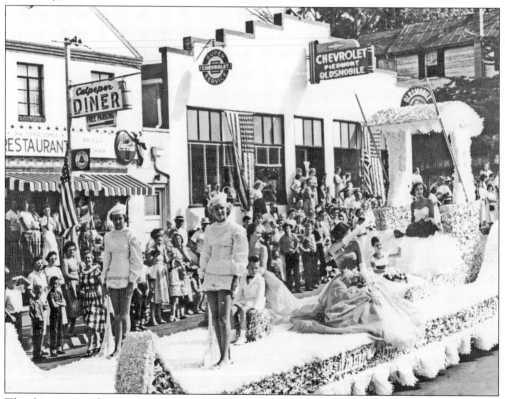

This bicentennial parade took place in 1959. The bicentennial celebration included many activities, such as the parade and plays. (Photograph courtesy of the J. R. Guinn Collection at the Culpeper Museum of History.)

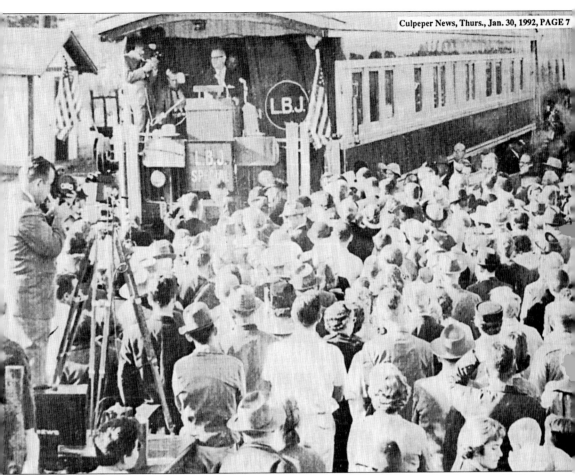

Lyndon B Johnson, candidate for vice president, appears before a crowd at the depot in 1960. (Photograph courtesy of Culpeper Museum of History.)

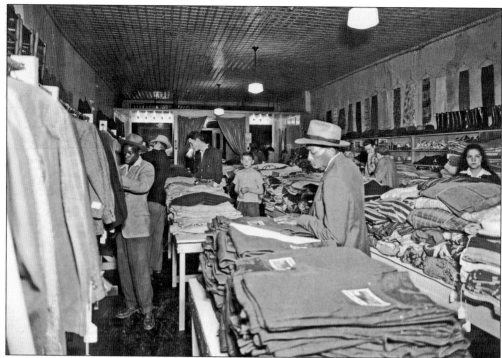

Unidentified shoppers in the A&N Store on East Davis Street look for bargains. (Courtesy of the Culpeper Museum of History.)

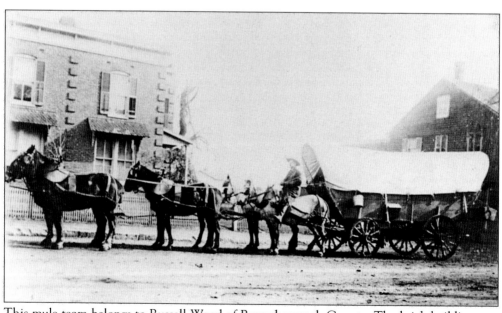

This mule team belongs to Russell Wood of Rappahannock County. The brick building was located on Davis Street. (Photograph courtesy of the Culpeper Museum of History.)

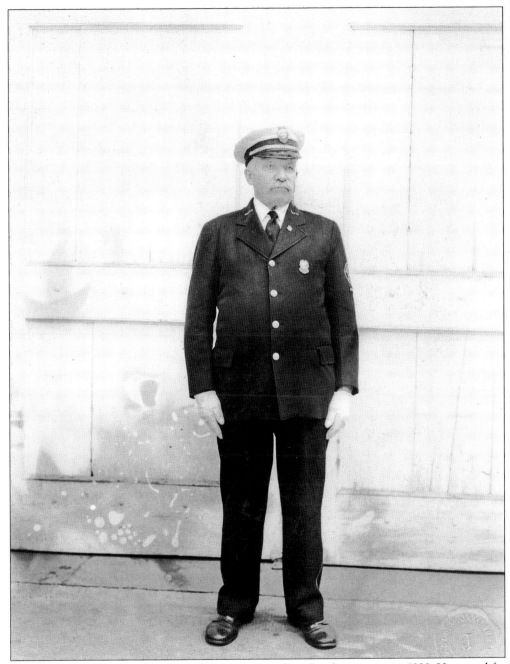

J. William Swan became fire chief of Culpeper's modern fire department in 1923. He served for 22 years. (Photograph courtesy of the Culpeper Museum of History.)

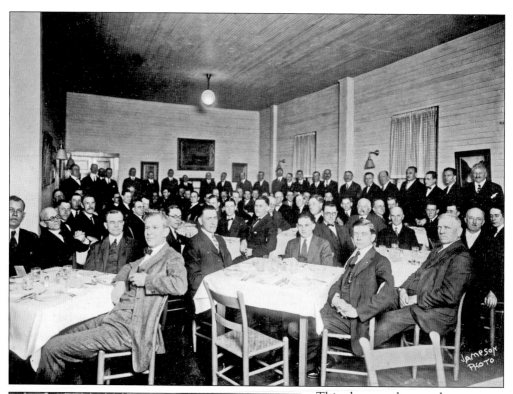

This photograph was taken of members of the chamber of commerce enjoying the annual Culpeper Chamber of Commerce Dinner in the municipal building on Davis Street in 1928. Some of the members identified are R. M. Aperson, Plummer Beard, John Bickers, Cornelius Bruce, J. B. Carpenter Sr., Stan Chapman, Mike Clark, John Covington, Robert Early, Walter A. Gloscock, Joseph Hudson, Wayman Johnson, Charles Hitt, and J. L. Fray. (Photograph courtesy of the Culpeper Museum of History.)

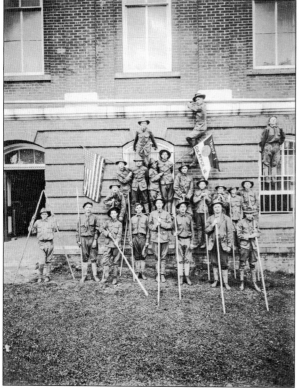

J. Gordon Thomas, commander (second from right, first row), and Culpeper Boy Scout Troop No. 1 are pictured around 1915. (Photograph courtesy of the Culpeper Museum of History.)

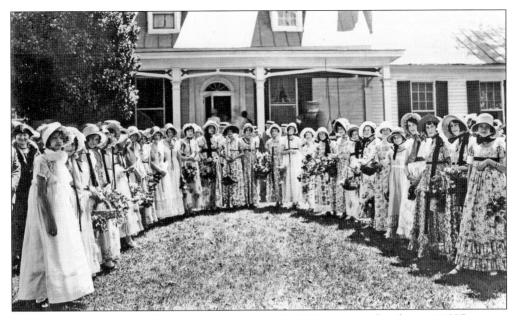

The Lafayette Pageant at Greenwood on August 22, 1925, reenacted Lafayette's 1825 visit to Culpeper. Greenwood, build around 1760, was the official welcoming site to the Marquis de Lafayette during his American tour. After enjoying locally produced apple brandy, he traveled to Culpeper and was received there by "the old soldiers of the Revolution." (Photograph courtesy of the J. R. Guinn Collection at the Culpeper Museum of History.)

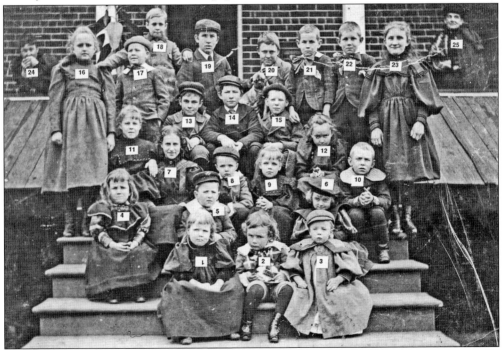

This birthday party was held at Somervilla around 1895. The birthday boy is Gassell Somerville Stringfellow, seated in the middle on the bottom step. (Photograph courtesy of the J. R. Guinn Collection at the Culpeper Museum of History.)

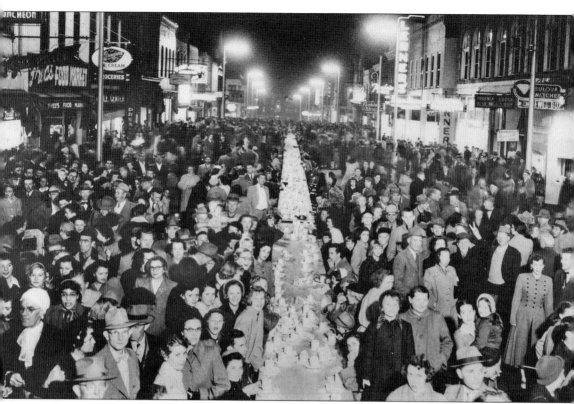

Pictured are some of the many participants in Culpeper's celebration of the first fluorescent streetlights south of the Mason-Dixon Line, an event named Operation Skyglow. The celebration boasted the "longest supper table in the world." (Photograph courtesy of the J. R. Guinn Collection at the Culpeper Museum of History.)

Pictured in the late 1920s is one of the many plays held in the Old Fairfax Theatre. The theater hosted everything from minstrel shows to boxing in the 1930s. It closed in 1954. (Photograph courtesy of the Culpeper Museum of History.)

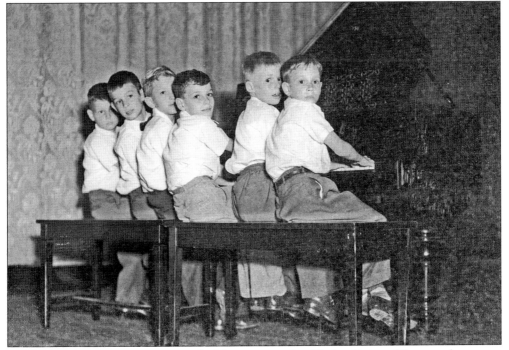

This 1950s piano sextet was comprised of the music pupils of Evelyn Guinn. (Photograph courtesy of the J. R. Guinn Collection at the Culpeper Museum of History.)

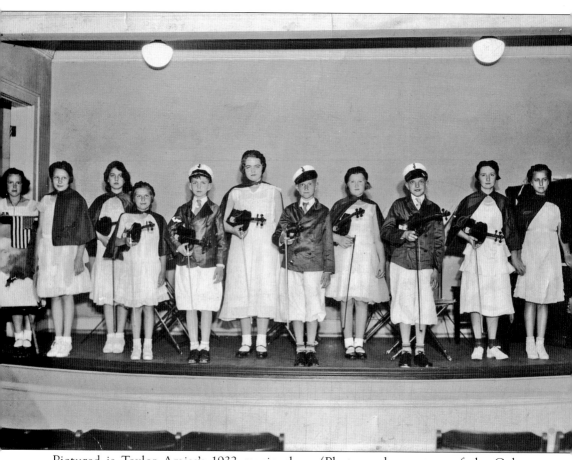

Pictured is Taylor Amiss's 1932 music class. (Photograph courtesy of the Culpeper Museum of History.)

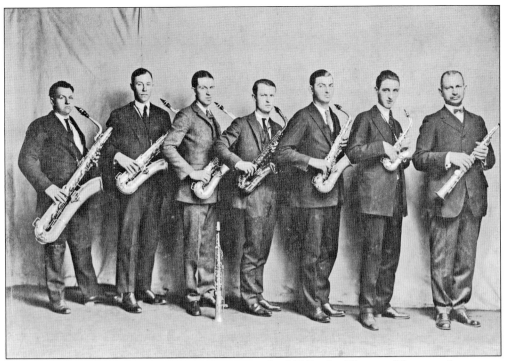

Pictured is a 1920s saxophone septet performing at the Old Fairfax Theatre. (Photograph courtesy of the Culpeper Museum of History.)

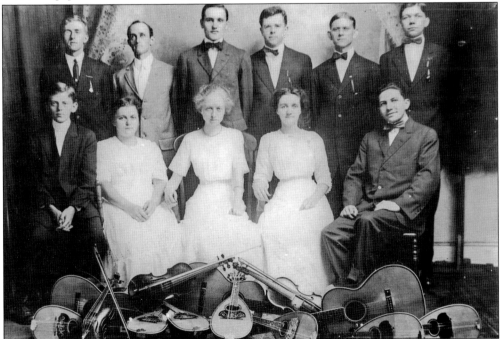

The Old Fairfax Theatre hosted many musicals and theatricals in the early 20th century, including the Culpeper Mandolin Club, pictured around 1912. (Photograph courtesy of the Culpeper Museum of History.)

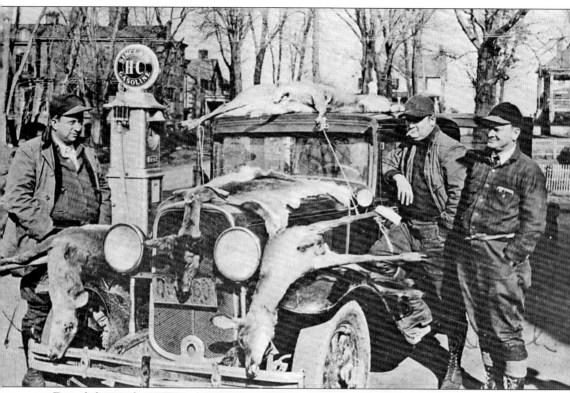

From left to right are Joseph B. Hudson Sr., Carroll T. Baker, and Dick C. Weaver returning from a hunting trip in Pennsylvania in the 1930s. (Photograph courtesy of the Culpeper Museum of History.)

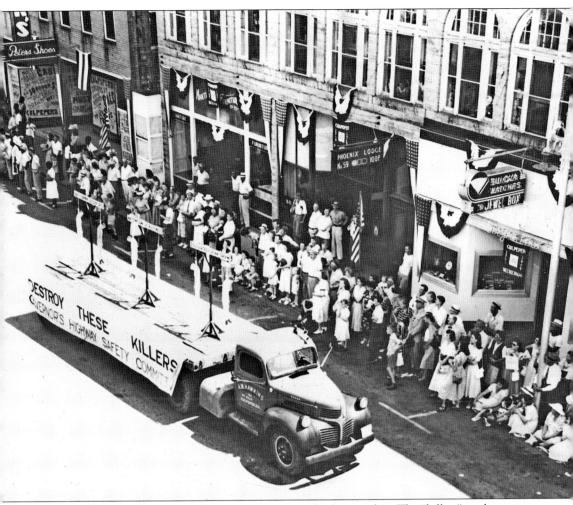

This 1949 Culpeper Centennial Parade float promotes highway safety. The "killers" are hung in effigy. (Photograph courtesy of the Culpeper Museum of History.)

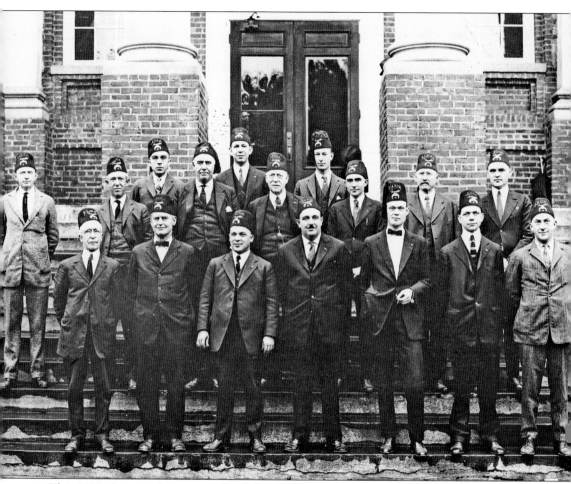

This 1924 photograph captures the Culpeper Shriners in front of the school on East Street. From left to right are (first row) Henry P. Walton, Lewis P. Nelson, W. Bowman Clark, J. C. Albright, Herbert Vaughan, T. Irvine Martin, and Dr. Harry B. Lacy; (second row) John Yowell, John J. Davies, J. MacZimmerman, Byrd Leavell, Cornelius S. Bruce, Jackson L. Fray Sr., Henry L. Hughes, Frank P. Jenkins, Haywood Settle, and Roy H. Hutcherson. (Photograph courtesy of the Culpeper Museum of History.)

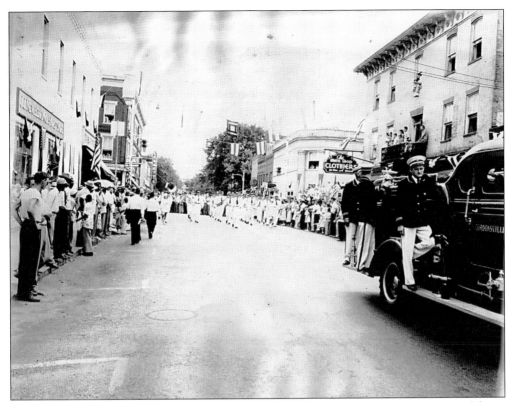

The Culpeper Centennial Parade, c. 1949, drew large crowds from the community to celebrate 200 years of Culpeper history. (Photograph courtesy of the Culpeper Museum of History.)

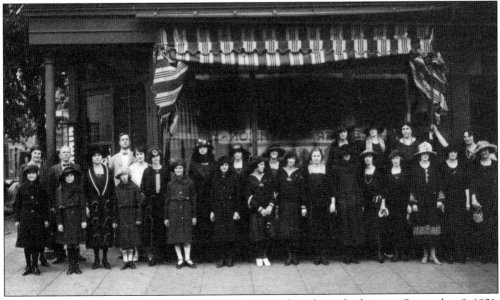

Some of Culpeper's attractive young ladies participated in the style show on September 9, 1921. The show was held at the store of E. J. Nottingham Jr. and Company. (Photograph courtesy of the Culpeper Museum of History.)

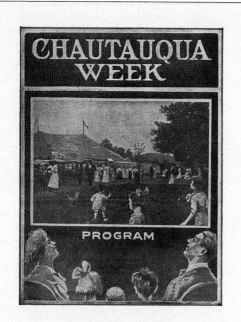

Culpeper, Virginia
August 22-28, 1914

As depicted by this program, Culpeper hosted a Chautauqua Week in 1914. Chautauqua is a week of cultural events that include music, art, book readings, and plays. (Photograph courtesy of the Culpeper Museum of History.)

This Chautauqua Week program gives a glimpse into the cultural activities of Culpeper. *The Mikado* is a well-known opera that toured many small towns that hosted the Chautauqua. (Photograph courtesy of the Culpeper Museum of History.)

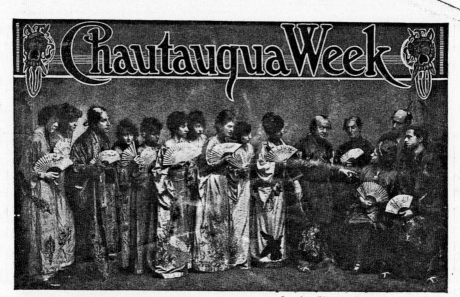

Scene from "The Mikado"

Seven Joyous Days | Culpeper, Va. July 8-14
Buy a Season Ticket, $2.00

The photograph appears to have been taken in the early 1900s. The handsome young men are, from left to right, George Frazier, William F. "Bill" Bywaters, Oswald Hudson, and Henry Smith. (Photograph courtesy of the Culpeper Museum of History.)

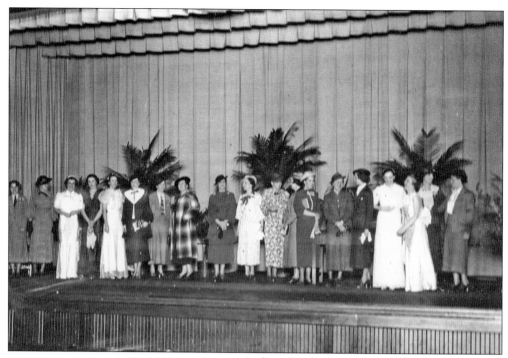

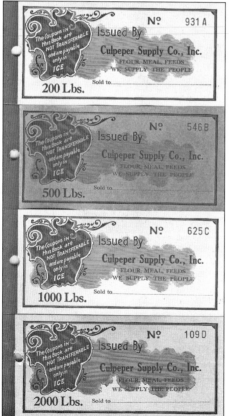

Ladies of Culpeper were very fashion conscious, as seen in this 1936 photograph of the style show. Some of the lovely models above are Robbie Partlow, Margaret Strothers, Frances Carpenter, Marjorie Inskeep, Mrs. E. W. Haley, D. Zaborill, E. Martin, Martha Johnson, Francis Kilby, Anna Marie Rue, Helen Jeffries, Francis Coleman, Letitia Roberts, Francis Huffman, Emma Jane Hagan, and Mary Inskeep. (Photograph courtesy of the Culpeper Museum of History.)

Coupon booklets were issued by the Culpeper Supply Company, Inc. The company advertised flour, meal, mill feed, corn hay, salt, and other farm supplies. Located on Commerce Street, it was organized during a feed scarcity in Culpeper and adjoining counties. Note the coupons in this book, some up to 2,000 pounds, could only be redeemed in ice. (Photograph courtesy of the Culpeper Museum of History.)

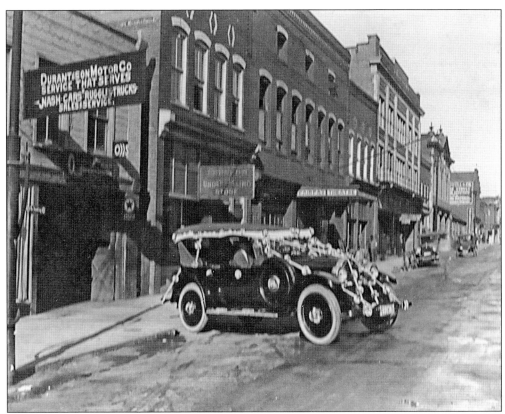

East Davis Street boasted a movie theater, a motor company, and an underselling store (a discount store). The car parked in front of Durant and Son Motor Company appears all dressed up for a special event. (Photograph courtesy of the Culpeper Museum of History.)

Culpeper residents enjoyed new releases at the Pitts Theatre. (Photograph courtesy of the State Theatre Foundation.)

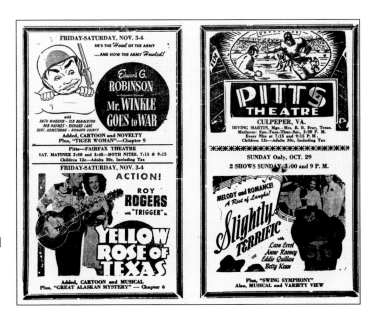

One of many music recitals held by local schools and private music teachers in Culpeper is pictured here. (Photograph courtesy of the Culpeper Museum of History.)

This is an unidentified photograph of a music recital similar to the previous picture. (Photograph courtesy of the Culpeper Museum of History.)

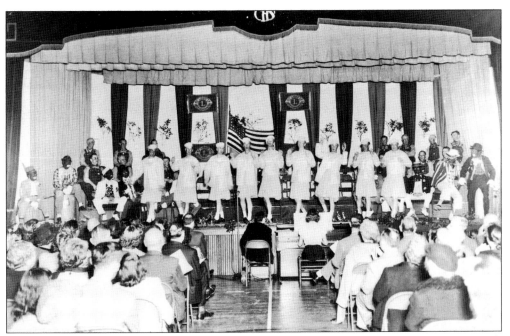

These dancing girls seem a bit too muscular. The photograph was taken at Culpeper High School. The Lions Club sign indicates the variety show may have been sponsored by the Lions. (Photograph courtesy of the Culpeper Museum of History.)

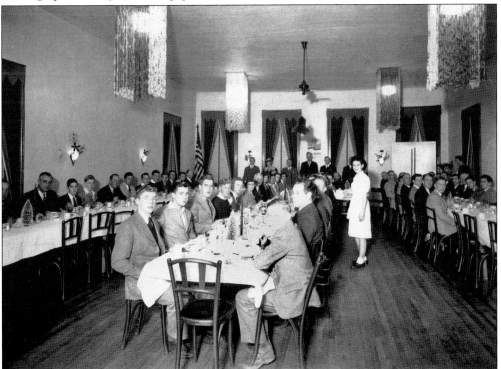

The Odd Fellows enjoy their Christmas banquet at the Waverly Hotel around 1910. (Photograph courtesy of the Culpeper Museum of History.)

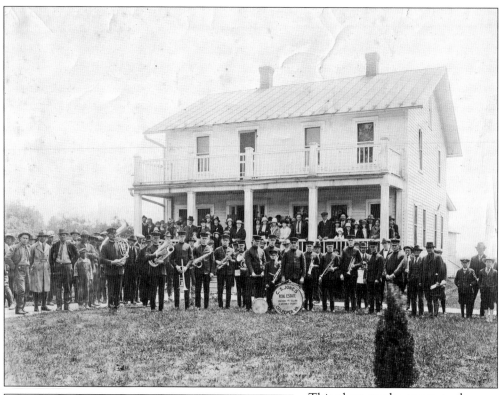

This photograph appears to show another Culpeper band in the early 1920s. (Photograph courtesy of the Culpeper Museum of History.)

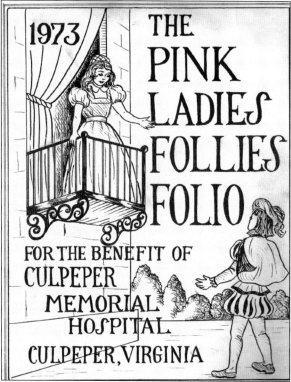

Pictured is the *Pink Ladies Follies* program booklet of the 1973 hospital benefit play. The play was directed by Browning Payne with Mrs. C. T. Ireland and Mrs. Paul Schwartz as pianists. Some of the advertisement slogans include: "No legacy is so rich as honesty" from the Second National Bank; "I'd gladly live in Culpeper forever and a day" from the Culpeper Chamber of Commerce, and "Friendly Service—The Best in Foods" from Toms Meat and Delicatessen Market. (Photograph courtesy of the Culpeper Museum of History.)

Two

EDUCATION, SPORTS, AND CHURCH

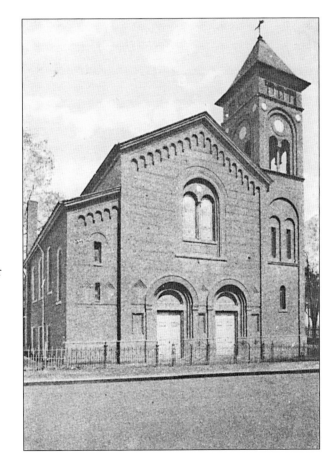

This postcard shows the Culpeper First Baptist Church at the corner of East Davis Street and East Street. The church building has stood on the corner of East and Davis Streets since 1858. The building is on the lot where the old jail stood. James Ireland and others were imprisoned there for preaching the gospel without a license in the state. (Postcard courtesy of the Culpeper Museum of History.)

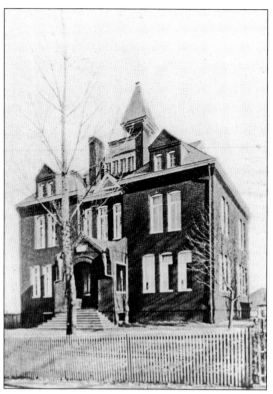

Culpeper's first school built with taxpayers' funds was constructed in 1892 at the cost of $12,000. It seated about 300 and stood on North East Street. Many thought it was too extravagant and that there would never be enough people in the county to fill it. (Photograph courtesy of the Culpeper Museum of History.)

The Home Demonstration Department gathers for their annual picnic on September 2, 1948. (Photograph courtesy of the Culpeper Museum of History.)

Pictured is the 40th class reunion of the class of 1926. (Photograph courtesy of the Culpeper Museum of History.)

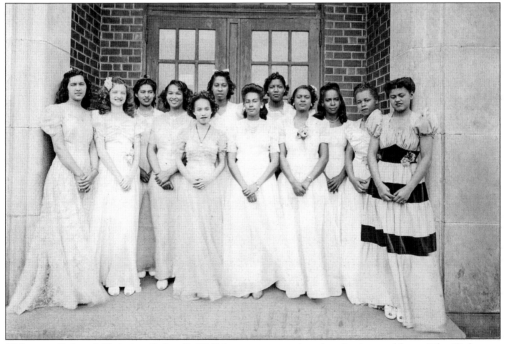

Culpeper Colored Training School's 1943 home economics class is pictured here. The Culpeper Colored Training School was opened in 1935 for African American children. (Photograph courtesy of the Culpeper Museum of History.)

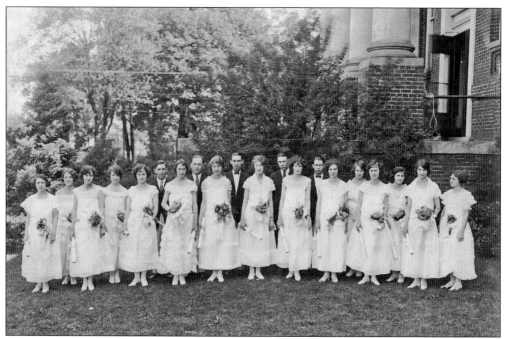

The Culpeper High School graduating class of 1924 is pictured here. Note that the girls are wearing white dresses and the young men are in suits instead of graduation gowns. (Photograph courtesy of the Culpeper Museum of History.)

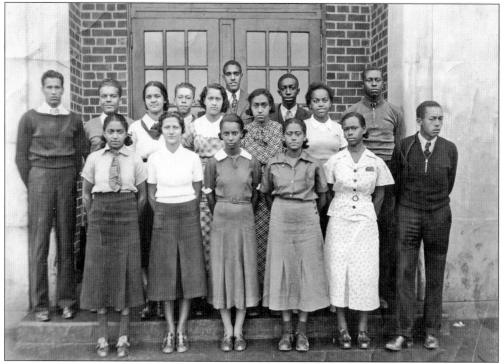

Pictured here is the first graduating class of the Culpeper Colored Training School (CCTS) in 1938. The school opened in 1935. (Photograph courtesy of the Culpeper Museum of History.)

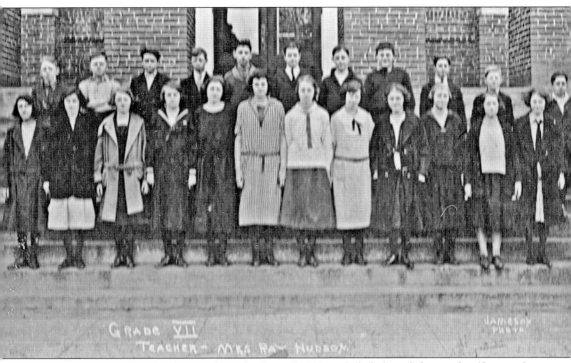

The Culpeper High School seventh-grade class of 1923 included, from left to right, (first row) Maggie Belle Anderson, Wilma Parr, Louise McAllister, Katherine Palmer, Dorothy Huffman, Evelyn Guinn, Edna Dodson, Elise Bywaters, Gertrude Judd, Roselle Spicer, Carolyn Stultz, and Earlena Doggett; (second row) Lewis Smith, George Mason (Bay) Green, Edward Printz, Eddie Sciater, Jack Walker, Silas Tappy, Walton May, John Buckner (Buck) Green, Raymond High, Alan (Pinky) Smith, and Henry Thompson. The photograph was taken by Anne Green Graves. (Photograph courtesy of the Culpeper Museum of History.)

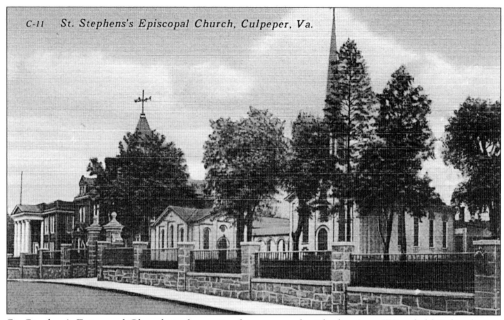

C-11 St. Stephens's Episcopal Church, Culpeper, Va.

St. Stephen's Episcopal Church is shown in this postcard with the Ann Wingfield School next door. (Postcard courtesy of the Culpeper Museum of History.)

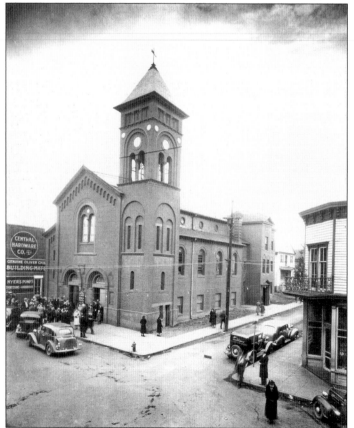

This postcard depicts the old Baptist church on East Davis Street and East Street. Fire destroyed the original building in 1892. Construction of a new building on the same spot was completed in 1894. (Postcard courtesy of John Lassiter.)

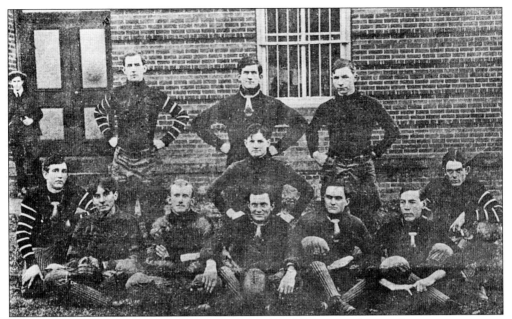

The 1911 Culpeper town football team is pictured as follows: standing in doorway is spectator Brockman Winfrey; from left to right are (first row) Lance Rust, Puller Hughes, Charlie Payne, Jim Roach, John S. Buckner, and Nelson Wamper; (second row) John Jones and George Towne; (third row) Frank Smith, Tyree Armstrong, and Mercer Nalle. (Photograph courtesy of the Culpeper Museum of History.)

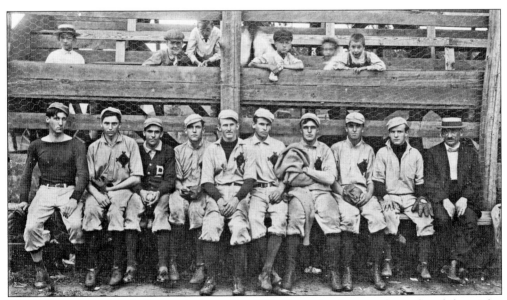

The Culpeper town baseball team is pictured in 1910. Shown in photograph are, from left to right, Louis Hawley, Robert Tinsley, Berry Lee Burgandine, Roy Kilby, Charlie Payne, Herndon Kilby, unidentified, Howard White, Bryant Smith, and R. P. "Bob" Whitestone, manager. (Photograph courtesy of the Culpeper Museum of History.)

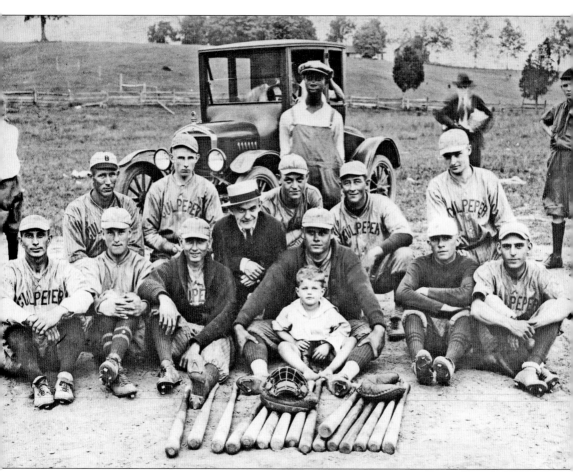

The Culpeper town baseball team is shown in 1920 at the old ball diamond on Rixeyville Road. From left to right are (first row) Bryan Spicer, "Pug" Bailey, Murat Willis, Cornelius "Tub" Smith, O. T. Herndon, and Edwin Gibson; (second row) Willis Norman, Russell Guinn, "Pug" Moncure (in a straw hat), Lewis "Shark" Morris, Joe Johnson, and Willie Morris; (standing in front of the Ford) water boy William "Smut" Lewis; (at right) Tasker Humphries. The batboy is unidentified. (Photograph courtesy of Culpeper Museum of History.)

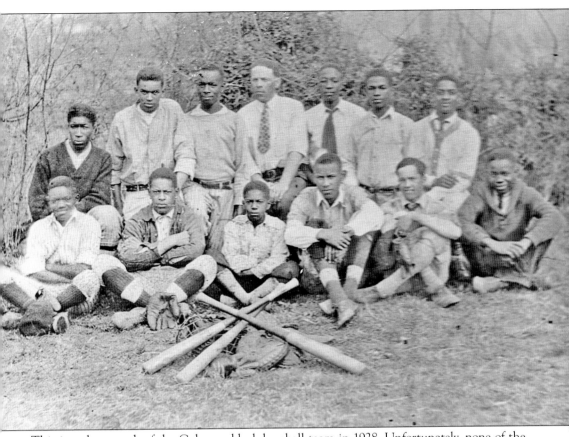

This is a photograph of the Culpeper black baseball team in 1928. Unfortunately, none of the players are identified. (Photograph courtesy of the Culpeper Museum of History.)

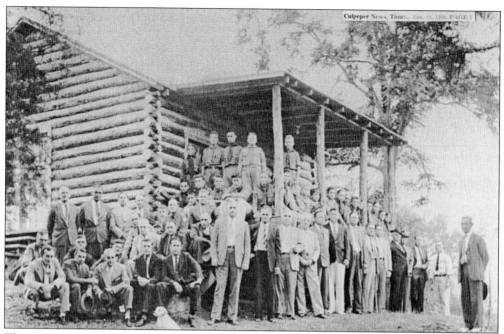

This 1940s photograph shows the Boy Scouts, sponsored by the Rotary Club of Culpeper, at the dedication ceremony of their new cabin. The cabin was located at the back of Jameson Hill near Mountain Run. (Photograph courtesy of Culpeper Museum of History.)

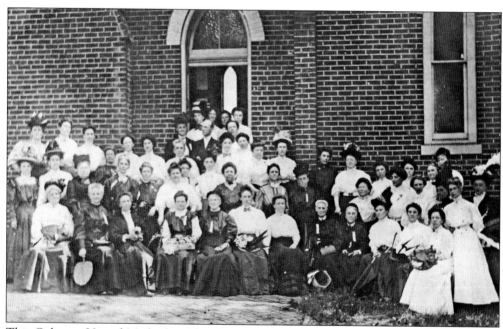

This Culpeper United Methodist Church class picture was taken in 1900 in front of the old Methodist church. The Culpeper Fire Hall now occupies the location. (Photograph courtesy of the Culpeper Museum of History.)

84

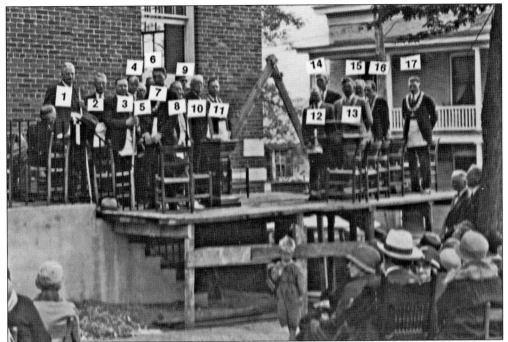

The photograph depicts the dedication of the Methodist church Sunday school building. The ceremony was conducted by the Masons on May 12, 1930. (Photograph courtesy of the Culpeper Museum of History.)

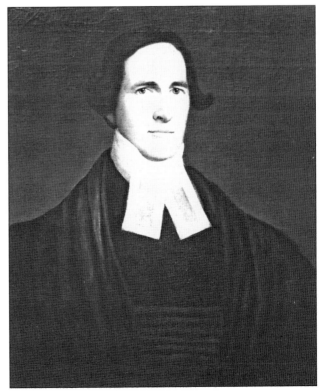

The Reverend Philip Slaughter (1808–1890) served as rector of Emmanuel Episcopal Church in Rapidan and wrote an extensive history of St. Mark's Parish. (Photograph courtesy of St. Stephen's Episcopal Church.)

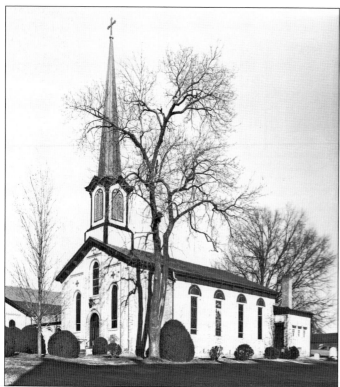

This photograph is a view of St. Stevens Church from the southeast corner, including the cemetery on the right and parish hall to the left. (Photograph courtesy of St. Stephen's Episcopal Church.)

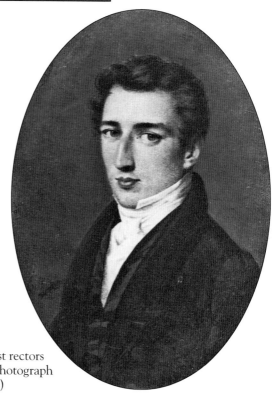

Rev. George A. Smith was one of the earliest rectors of St. Stevens, serving from 1827 to 1831. (Photograph courtesy of St. Stephen's Episcopal Church.)

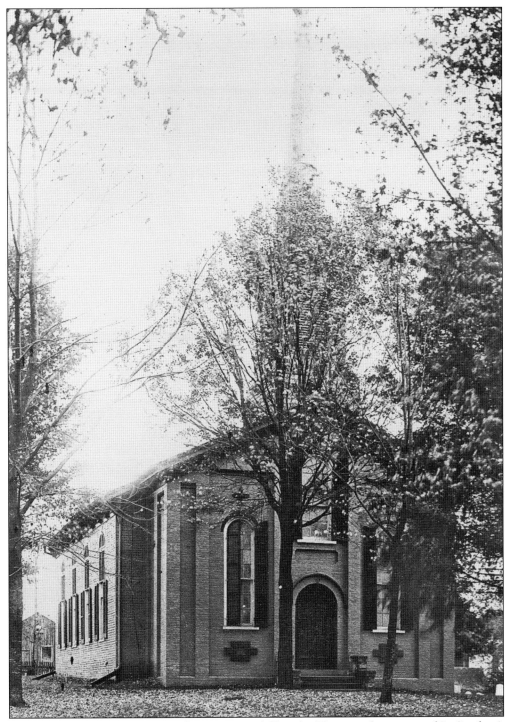

A 1902 photograph shows St. Stephen's Episcopal Church. (Photograph courtesy of St. Stephen's Episcopal Church.)

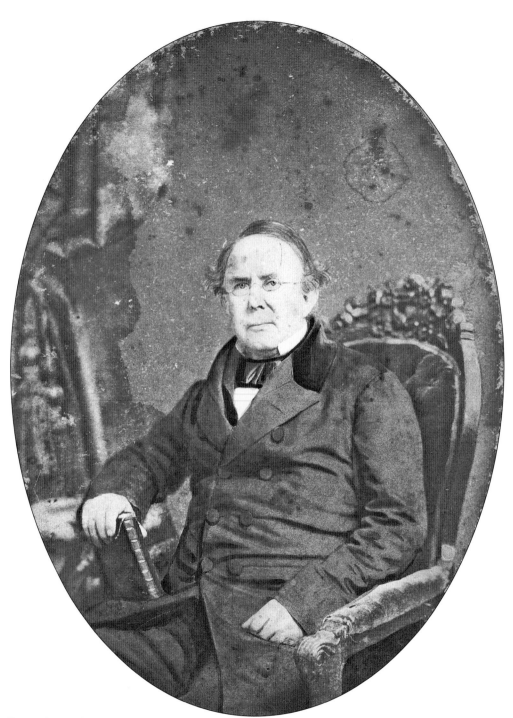

Rev. John Cole served as rector of St. Stephen's Episcopal Church during the Civil War. In his annual report during the 1863–1864 winter encampment, he wrote to the bishop that "the roar of the cannons and the blasts of the bugle have superseded the songs of the sanctuary and darkness hangs over the land. I have had over 400 funerals this year." (Photograph courtesy of St. Stephen's Episcopal Church.)

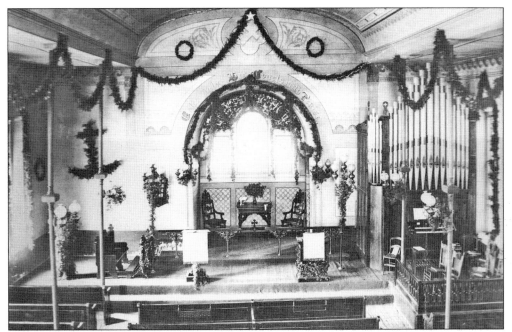

The sanctuary of St. Stephen's Episcopal Church is decked out in garlands and wreaths decorated for the Christmas holidays. At the time of this photograph, the 1890s fresco paintings by Joseph Oddenino were still a part of the church's interior. (Photograph courtesy of St. Stephen's Episcopal Church.)

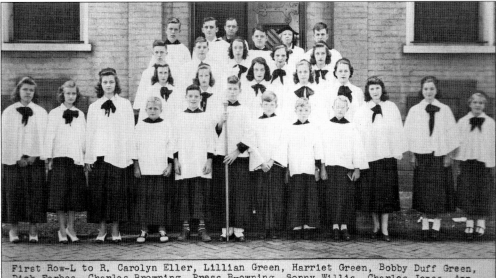

First Row-L to R. Carolyn Eller, Lillian Green, Harriet Green, Bobby Duff Green, Dick Forbes, Charles Browning, Press Browning, Sonny Willis, Charles Jones, Ann Browning, Peggy Jeffries and Kennon Eller. Second Row-- Katherine Yancey, Elizabeth Roberts, Peyton Lewis (visitor) Katherine Palmer and Elizabeth Reid Brown. Third Row--Malcolm Crump, Cameron Thompson, Ann Forbes, Nell Milford and Ada Newton Nalle. Fourth Row-- Sonny Williams, Angus Green, Blanton Duncan (visitor) Miss Elizabeth Hooper and Jack Jeffries Jr. Fifth Row-- Rev. James E. Bethea--Rector.

This photograph shows one of the St. Stephen's Episcopal Church choirs. The names of choir members are located on the bottom of the photograph. (Photograph courtesy of St. Stephen's Episcopal Church.)

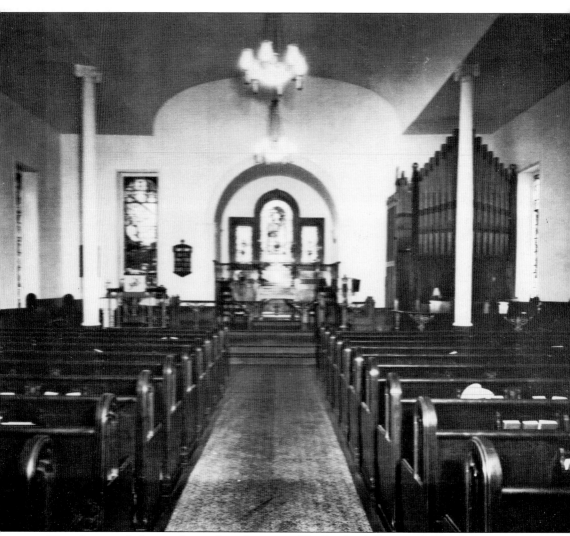

This photograph depicts the modern-day view of St. Stephen's Episcopal Church sanctuary. St. Steven's, located on land donated by local Revolutionary war hero Gen. Edward Stevens, is the oldest church in the town of Culpeper. Although the cornerstone dates the building to 1821, the congregation was recognized and accepted as a member at the Diocesan Council in 1815. St. Stevens grew steadily in the 1800s and reported a Sunday school membership of 200 with approximately one-half being African American. During the Civil War it was used as a hospital for the casualties from the battle of Cedar Mountain. St. Stevens and Culpeper Baptist Church were the only two churches not destroyed during the war. (Photograph courtesy of St. Stephen's Episcopal Church.)

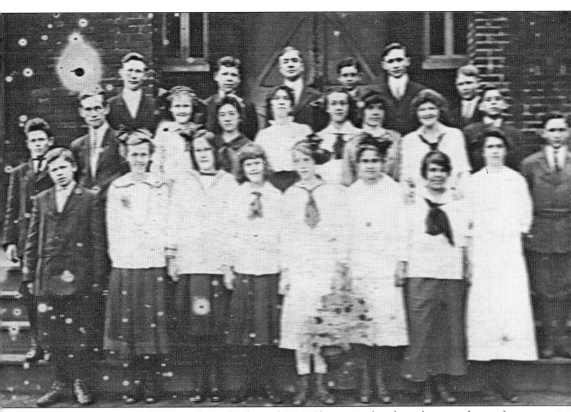

The photograph is of the seventh-grade class of 1914. Shown in the class photograph are, from left to right, (first row) Louis Fleaganes, Mildred George, Zella Finks, Mildred Gibson, Virginia Hitt, Nan Woolfolk, Myrtle Walter, and Evans Bragg; (second row) Dennis May, George Cardwell, Lucille Inskeep, Florrie Hoffman, Edna Wine, Emma Rosson, Emma Glascock, Elizabeth Puryear, and Edwin Gibson; (third row) Ashby Curtis, Paul Johnson, Ashby Burton, Aldelbert Smith, Frank Royston, and Willis Morris. (Photograph courtesy of the Culpeper Museum of History.)

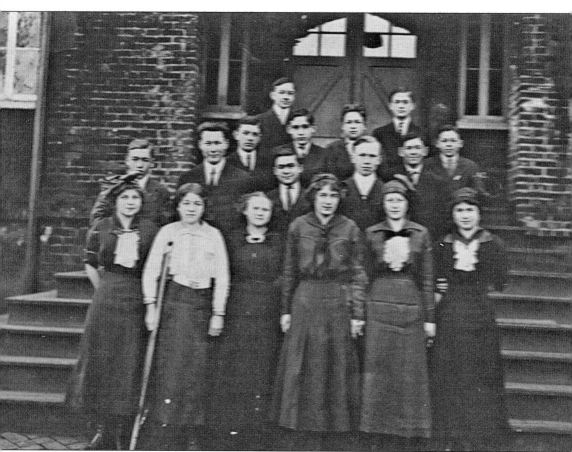

The photograph above shows the sophomore class of 1913 standing in front of Culpeper High School. Pictured are, from left to right, (first row) Carlyn Disner, Mollie Fitzgerald, Mae Clarke, Martha Haush, Mary Clore, and Ester Aperson; (second row) Gus Thornton, Fred Thomas, Frank Woolfolk, Charles Bolen, and John Rosson; (third row) Leon Hoffman, Johnathan Gibson, John Richard Reames, and Hobart Burnes; (fourth row) H. B. Winfrey and Johnson Strother. (Photograph courtesy of the Culpeper Museum of History.)

Three

LIFE IN A SMALL TOWN

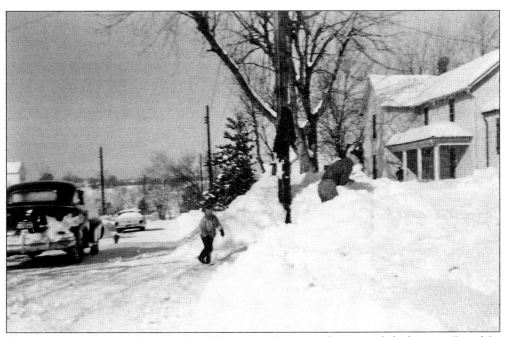

This early 1945 photograph shows David Kinzer Jr. playing in the snow while directing David Sr. how to dig out. The blizzard of 1962 was declared the worst winter snowstorm of the 20th century in Culpeper. Some areas received as much as 36 inches of snow. It is difficult to tell how deep the snow is in this photograph. (Photograph courtesy of the Kinzer family collection.)

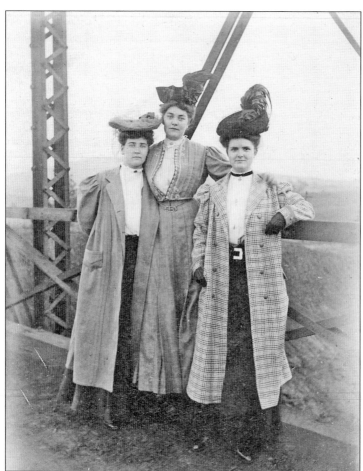

From left to right, Mary Jasper, Agnes Selander (a cousin), and Aunt Vennie are shown on vacation. Mary Jasper's husband died in 1925. She raised the children in the house on Park Avenue that her husband purchased from the Presbyterian church trustees in 1918. She took in boarders to support herself and her children. (Photograph courtesy of David Kinzer III.)

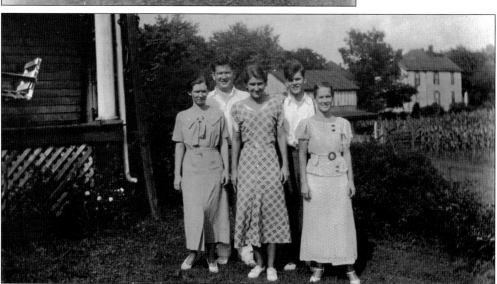

This group photograph shows the Jasper family—Virginia, Robert, Agnes, Alvin, and Edith. They grew up in the Jasper house at 314 Park Avenue. (Photograph courtesy of David Kinzer III.)

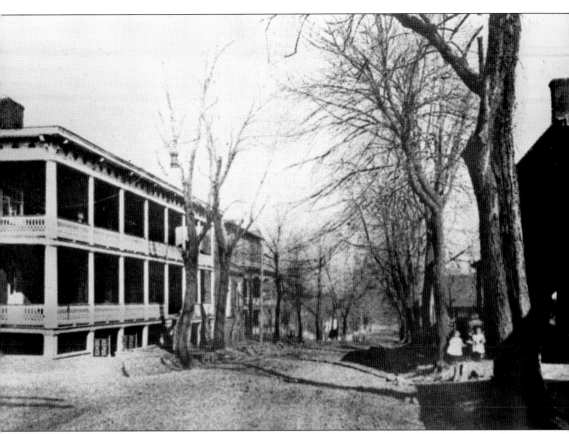

Pictured here is the Virginia Hotel, a very popular establishment in the mid-1800s. During the Civil War, most notables on both sides of the war stayed here. The hotel was located on Main Street in downtown Culpeper. The building now houses various businesses on the first floor, and the second floor is residential. (Photograph courtesy of Diane Logan.)

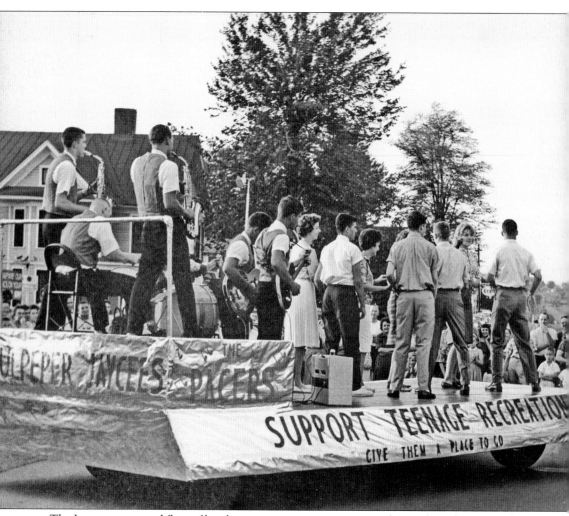

The Jaycees-sponsored float of local teenagers promotes recreation for youth in the 1962 Culpeper Fireman's Parade. David Kinzer Jr. played drums in a local band, the Pacers. (Photograph courtesy of the David Kinzer III collection.)

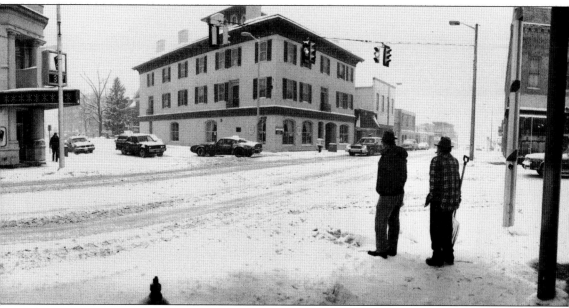

This image of a snow scene was taken at the corner of Davis and Main Streets during the 1960s. The building at far left is the boyhood home of Gen. A. T. Hill. (Photograph courtesy of Diane Logan.)

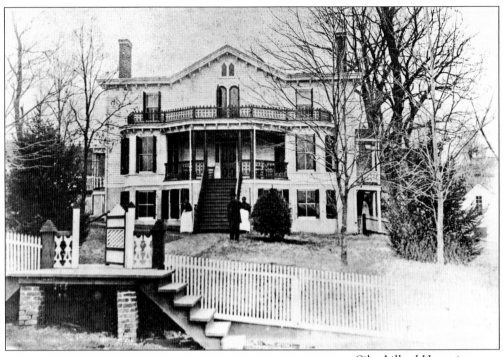

Silas Lillard Home is one of the many Victorian houses that surround the downtown commercial district. Note the steps and platform used to board horses or buggies. (Photograph courtesy of the J. R. Guinn Collection at the Culpeper Museum of History.)

Mr. and Mrs. Byrd Leavell are pictured. Byrd Leavell served on town council and as a member of the Culpeper Shriners. (Photograph courtesy of the Culpeper Museum of History.)

Piedmont Street is shown in a postcard produced by Latham Stores, located in downtown Culpeper. (Postcard courtesy of the Culpeper Museum of History.)

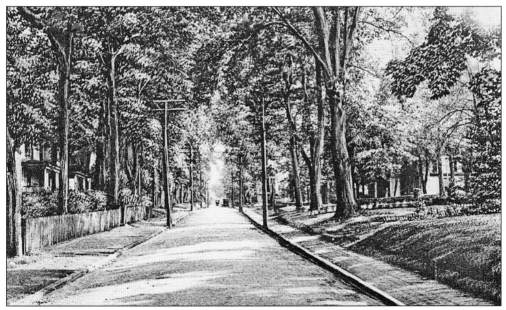

East Street runs through one of Culpeper's historic neighborhoods. (Postcard courtesy of the Culpeper Museum of History.)

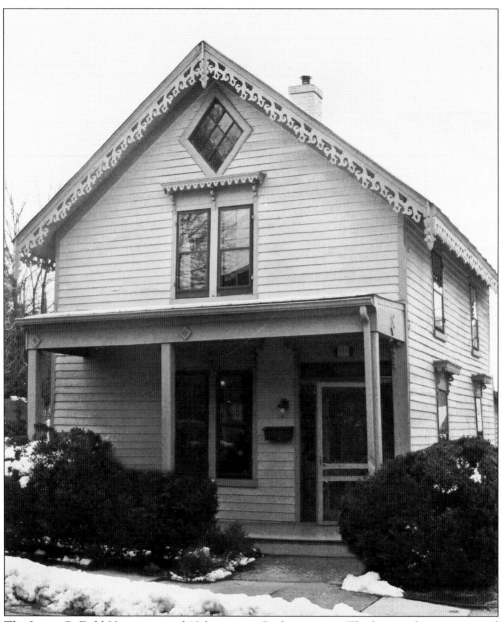

The James G. Field House is a mid-19th-century Gothic cottage. The historic home is opened periodically to the public with guided tours to benefit the Culpeper Museum of History. (Postcard courtesy of Brian Strecker.)

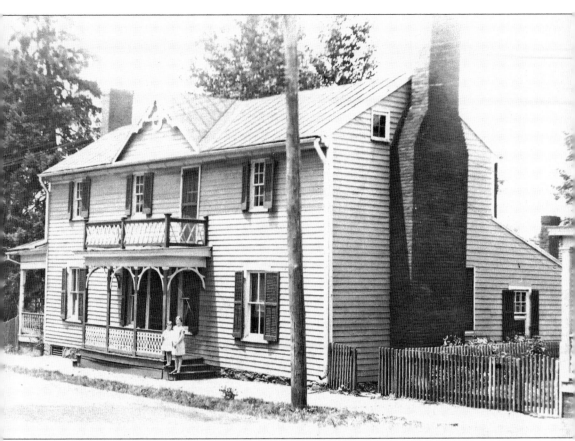

The David Bailey house was located at the corner of Main and Locust Streets. It was reported to be one of the oldest residences in the town of Culpeper before being demolished. (Photograph courtesy of the Culpeper Museum of History.)

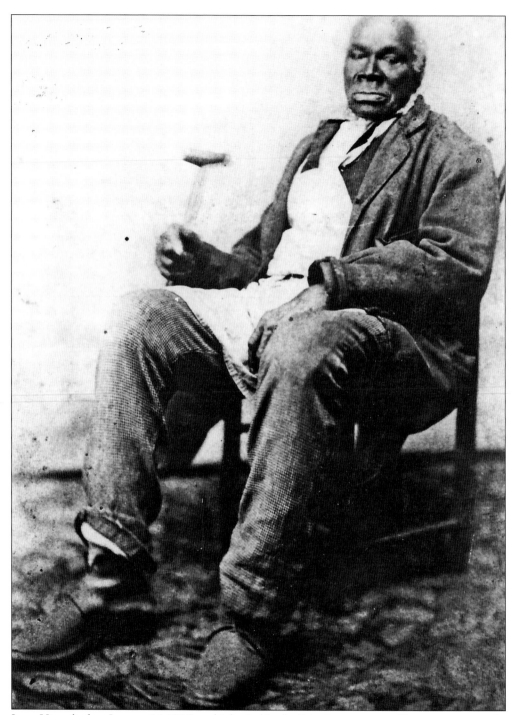

Isaac Hiter died on January 14, 1886, and is buried in the Fairview cemetery. His gravestone reads, "For 62 years, a faithful and consistent member of the Baptist church, white, Culpeper, VA age 104," and includes Isaac's Prayer: "Oh! Lord remember us in mercy and lead us safely through the low lands of sorrow. Deliver us from every lock and chain, and make this world as peaceful as two turtle doves in a nest." (Photograph courtesy of the Culpeper Museum of History.)

Four

MILITARY ACTIVITY

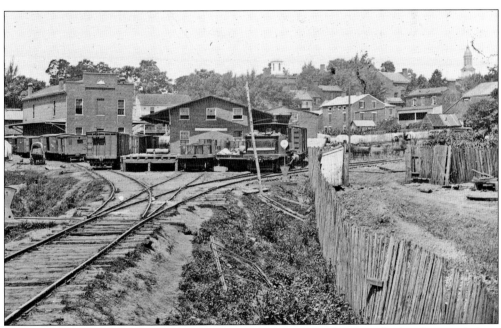

Washington, D.C., the seat of the Union government, was only a day's horseback or buggy ride from Culpeper. The railroad made travel, troop movement, delivery of supplies, and so forth easier, and Culpeper became easily accessible, making it strategically valuable to both armies. Strategically located Culpeper was continuously occupied during the Civil War. Troops quartered in and around the town. Constant scavenging for food and firewood devastated the town and county. Grant wintered an army of 100,000 men in 1863–1864. Stuart and Fritz Lee headquartered in Culpeper, and the town was the beginning of several Southern invasions north. The occupying armies drained the resources of the community. It would take Culpeper many years to repair homes, shops, and farms and recover from the devastation of war. Postwar Culpeper hosted Civil War Veteran reunions. This photograph shows the Culpeper Railroad depot and yard in 1862. Since Culpeper's earliest history, there have been military organizations ready to protect and serve. (Photograph courtesy of the Civil War Treasures from the New York Historical Society.)

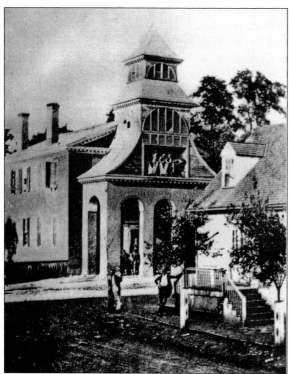

This photograph shows Confederate prisoners standing on the balcony of the Culpeper Courthouse. These prisoners were captured at the Battle of Cedar Mountain on August 9, 1862. (Photograph courtesy of the Culpeper Museum of History.)

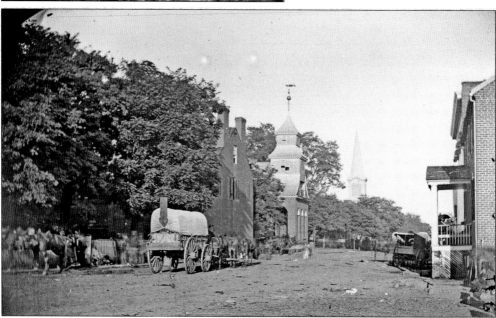

This 1862 Culpeper scene shows the A. P. Hill home on the left. The Culpeper Court House is also shown on the left, with the Culpeper Baptist Church steeple in the foreground. Hill fought in the Mexican War and the Seminole Wars. Hill, known as "Little Powell," commanded the famous "Light Division" and was described by Lee as one of his best commanders. He was killed just before Appomattox. Both Lee and Jackson called for A. P. Hill in their dying breaths. (Photograph courtesy of the Civil War collection of the Library of Congress.)

This photograph captures wounded soldiers held prisoner after the Battle of Cedar Mountain. (Photograph courtesy of the Culpeper Museum of History.)

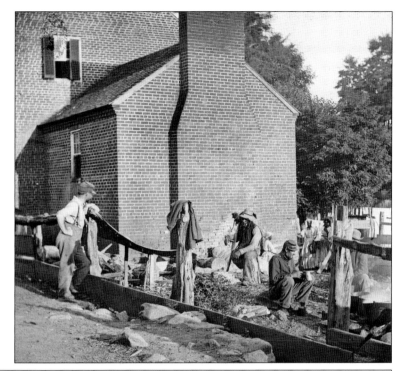

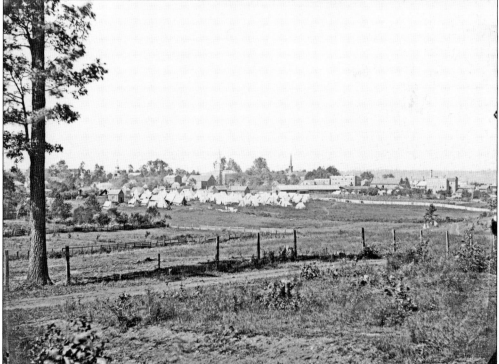

This 1863 image is of an encampment on the edge of town. It is taken from *Civil War Photographs, 1861–1865* compiled by Hirst D. Hilhollen and Donald H. Mugridge. (Photograph courtesy of the Library of Congress, 1977. No. 0204.)

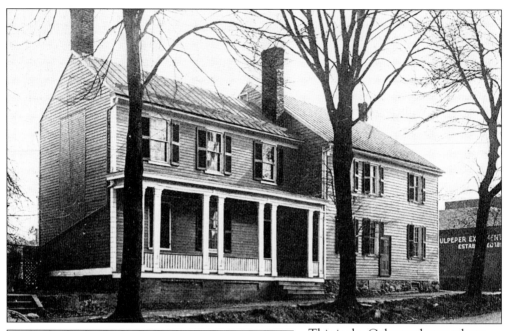

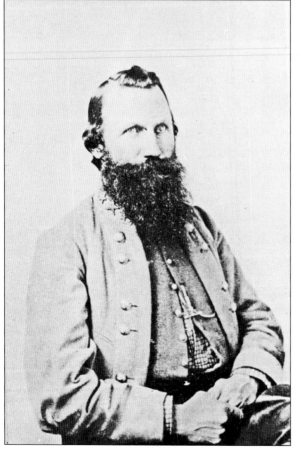

This is the Culpeper house where Lt. Col. John Pelham died. Pelham fought with valor and dedication to the Confederate cause. Gen. J. E. B. Stuart was so impressed with the young commander at the First Battle of Manassas that he recommended Pelham form and lead a six-gun horse artillery attached to the cavalry. Pelham was severely wounded in the Battle of Kelly's Ford. (Photograph courtesy of the J. R. Guinn Collection at the Culpeper Museum of History.)

J. E. B. Stuart was among the many Confederate officers who headquartered here frequently during the war. (Photograph courtesy of the Culpeper Museum of History.)

Confederate veterans attended the dedication of the Confederate Monument on the courthouse lawn on May 31, 1911. Identified veterans are Philip Jameson, Jerry Collins, Lee Collins, John Wesley Collins, Benoni Nalls, William Morris, John A. Holtzman, J. M. Beckham, G. B. W. Nalle, Charles B. Williams, R. P. Thrall, W. H. "Billy" Fray, W. P. "Billy" Hill, R. M. Mackall, H. C. Burrows, Tom Slaughter. Non-veterans are, at far left, Edwin Slaughter and, at far right, J. George Hiden. (Photograph courtesy of the Culpeper Museum of History.)

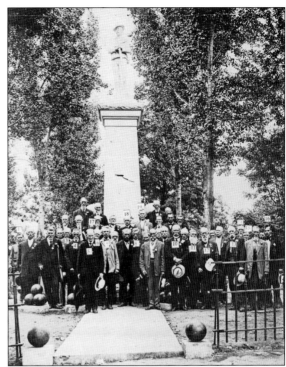

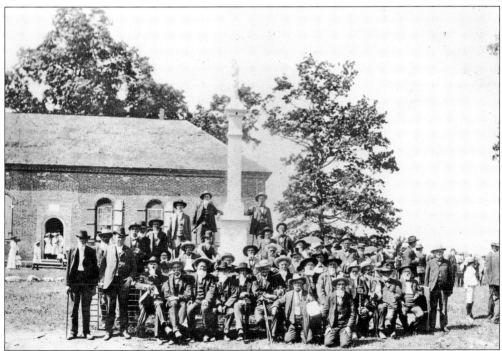

The Little Fork Rangers monument was unveiled on May 25, 1904, at Little Fork Episcopal Church. Among the Culpeper Minute Men are Harvey Heflin, J. A. "Jim" Swan, John Fray, Gentry Thrall, Malcolm Turbyfill, and Charlie Kilby. (Photograph courtesy of the Culpeper Museum of History.)

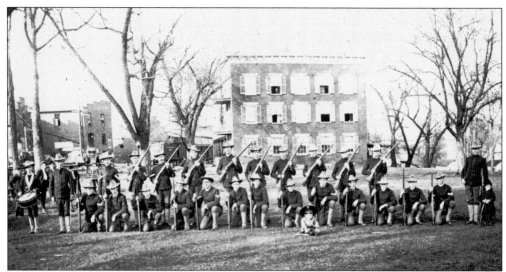

This *c.* 1904 photograph of the Culpeper Minute Men was taken at the south end of the old Waverly Hotel, near the depot. (Photograph courtesy of the J. R. Guinn Collection at the Culpeper Museum of History.)

Minute Men attended the dedication of the Confederate Monument on the courthouse lawn in 1911. Some of those identified are Aubrey Whitlock, Guy May, Maj. Edwin Slaughter and his daughter Gertrude, Malcolm Turbyfill, Major Kerrick, Malcomb Crump, Robert Tinsley, John Covington, Bob Lamon, Carlton Aperson, Cave Major, Aubrey Brown, John Duncan, Harvey Heflin, George Hudson, ? Russell, and ? Herndon. At right are Carlyn Diener and Ester Aperson. (Photograph courtesy of the J. R. Guinn Collection at the Culpeper Museum of History.)

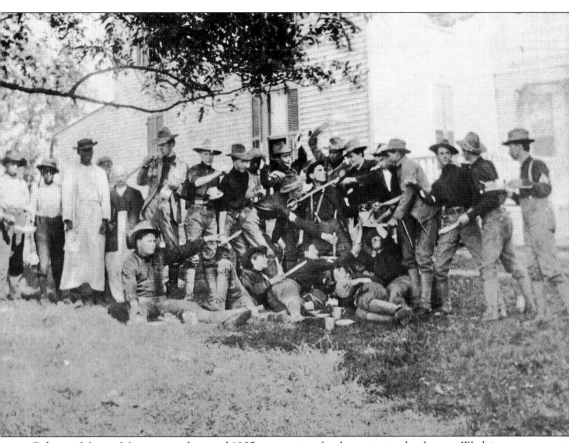

Culpeper Minute Men, pictured around 1905, are waiting for the train to take them to Washington, D.C., for the inauguration of Theodore Roosevelt as president. (Photograph courtesy of the J. R. Guinn Collection at the Culpeper Museum of History.)

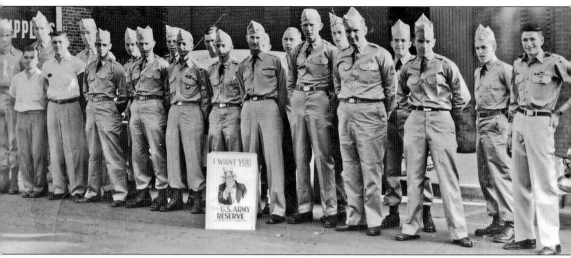

Pictured is the Culpeper unit of the U.S. Army Reserve around 1955. (Photograph courtesy of the Culpeper Museum of History.)

Billy Magun's real name is unknown. He was a Federal soldier captured at the Battle of Cedar Mountain. A severe head wound affected his mind and memory; he was taken care of by the Culpeper County authorities at Poor Town for 50 years, until his death in 1913. Although many attempts were made to find his relatives, they all proved futile. (Photograph courtesy of the Culpeper Museum of History.)

Capt. R. P. Thrall was one of Quantrill's men and a contemporary of the notorious outlaw Jesse James. Thrall came to Culpeper after the Civil War because of his wife's ill health. He had a small farm on the Sperryville Pike a few miles from town. He was a sign painter and fortune teller. Captain Thrall was a Confederate veteran and a well-known character in the town and county. He died in 1930. (Photograph courtesy of the Culpeper Museum of History.)

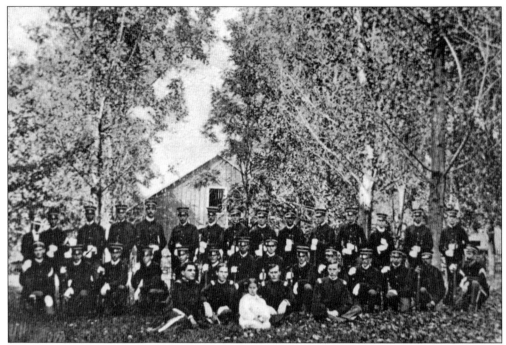

This is an early-1900s photograph of the Culpeper Minute Men on the courthouse lawn. The building in the background is an old livery stable on Cameron Street. Those identified in the photograph are, seated from left to right, Maj. Edwin Gibson, unidentified, Gertrude Slaughter, Maj. Edwin L. Slaughter, and Lt. Nick Wampler. (Photograph courtesy of the Culpeper Museum of History.)

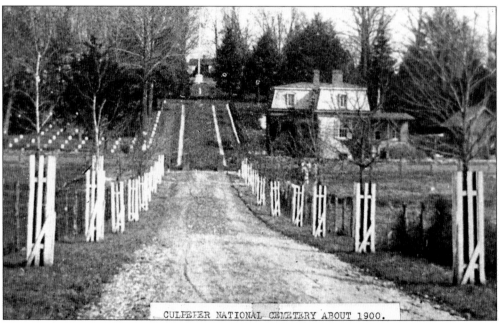

CULPEPER NATIONAL CEMETERY ABOUT 1900.

This is an early-1900s photograph of the Culpeper National Cemetery. (Photograph courtesy of the Culpeper Museum of History.)

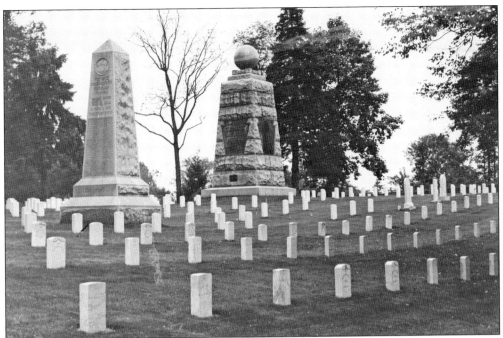

The Culpeper National Cemetery was established in 1867 by the U.S. government as a burial place for Union troops who died in the area during the Civil War. The cemetery is listed on the National Register of Historic Places. (Photograph courtesy of the Culpeper Museum of History.)

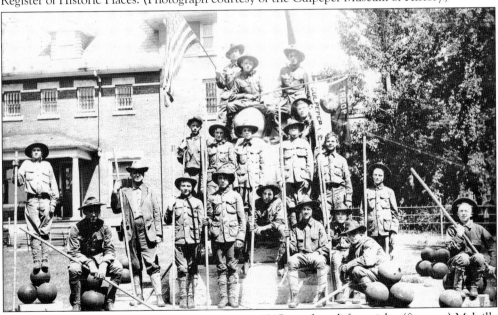

Posing in front of the Confederate Monument in 1915 are, from left to right, (first row) Melville Jeffres, John Arnold, Scoutmaster Gordon Thomas, Robert England, Rutherford England, Alex Kelly, Archie Briggs, William Aylor, Carroll Thomas, Carleton Guinn, and Lewis Bolen; (second row) Herbert Scott, Elmo Whitestone, Carter Goldsborough, Marion Jeffries, and George Bundick; (third row) Douglas Swan, Travers Green, Lyle Roadhouse, and Edwin Gaines. (Photograph courtesy of the Culpeper Museum of History.)

This 1920s photograph by George M. Jameson captures the Camp of Confederate Veterans of Virginia. The Camp reunion was held in Culpeper August 10, 11, and 12, 1920. (Photograph courtesy of the Culpeper Museum of History.)

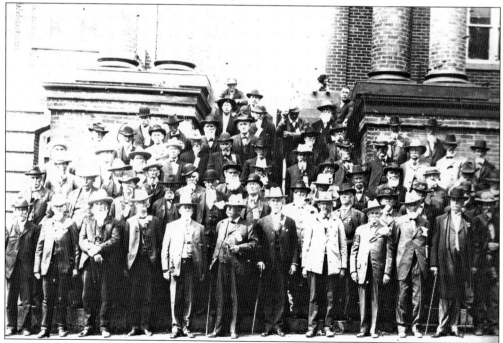

This 1906 photograph shows Culpeper's Confederate veterans standing on the steps of the Culpeper County Courthouse. (Photograph courtesy of the Culpeper Museum of History.)

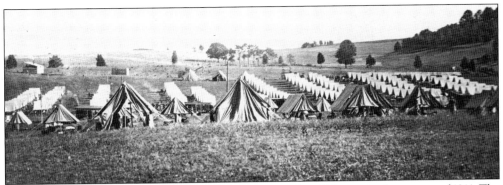

National Guard companies from all over Virginia converged on Culpeper in the summer of 1911. The camp depicted here was called Camp Sale in honor of Gen. W. W. Sale, adjutant general of Virginia at the time of the encampment. (Photograph courtesy of the Culpeper Museum of History.)

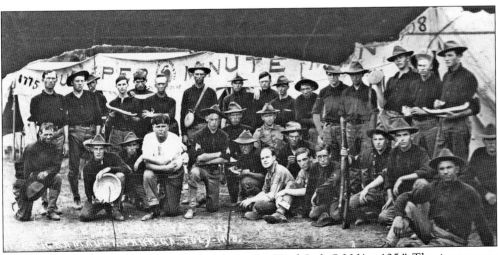

This photograph is titled "the Boys of Co. B. 72nd Inf. Of VA #125." The image was taken at Chickamauga Park, Georgia, in July 1918. (Photograph courtesy of the Culpeper Museum of History.)

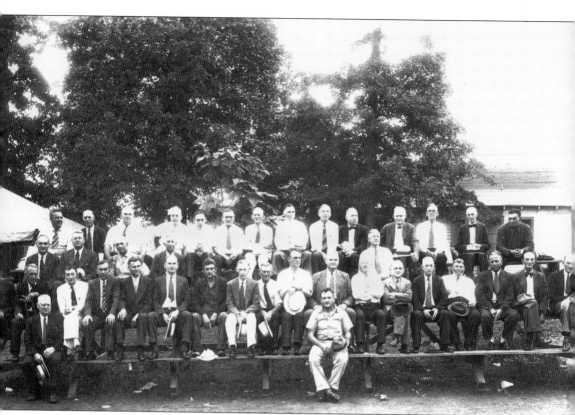

Members of the Culpeper Minute Men Association pose for this photograph on August 30, 1940. From left to right are (first row) Rufus G. Roberts and Walter Willoby (center); (second row) Russell Morris, Joe Grant, Wayman Johnson, Everett Reams, Roy Kilby, Hunter Kilby, Shelton Heflin, Aubrey Whitlock, Bill Jeffries, Jim Hawkins, Major Kerrick, Press Browning, Capt. Jim Green, Jim Swan, Bill Jones, Guy Tuel, Cliff Herndon, and Lewis Herndon; (third row) Roy Hutcherson, Ham Newhouse, Harvey Heflin, Capt. Tom Hooper, and George Norris (far right); (fourth row) Jack Taliaferro, unidentified, John Ed Duncan, Jimmy Kreticos (not a Minute Man), John Tinsley, George Clarke, George Hudson, Robert Tinsley, Cave Major, Malcolm Crump, L. P. Nelson Sr., S. T. Byrum, Johnny Shotwell, and John Barber. (Photograph courtesy of the Culpeper Museum of History.)

Five

POSTCARDS AND SNAPSHOTS

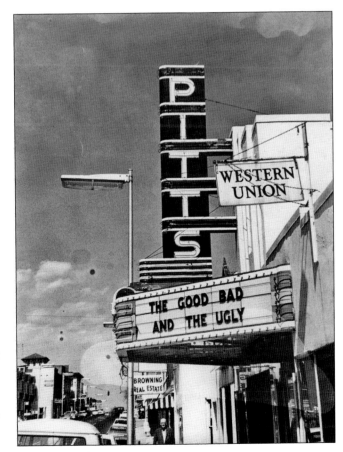

The popular Pitts Theatre was built in 1938. It is the best example of the few art deco–style buildings in Culpeper. The first picture shown at the Pitts was *Sally, Irene and Mary*. (Photograph courtesy of the State Theatre Foundation.)

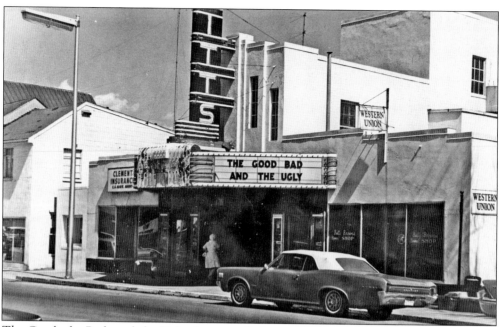

The Good, the Bad, and the Ugly shows in Culpeper. (Photograph courtesy of the State Theatre Foundation.)

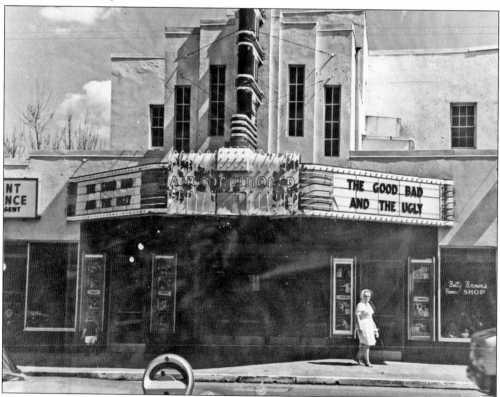

The marquee promoted the new release of *The Good, the Bad, and the Ugly.* (Photograph courtesy of the State Theatre Foundation.)

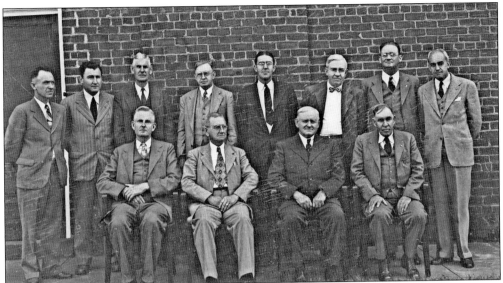

The board of directors of the National Bank in the 1950s are pictured here. Included in the photograph are William Cannon, Richard Jones, Otis Thornhill, John Yowell, Giles Miller, Dr. Granville Eastham, Wert Hurt, and P. W. Fore. (Photograph courtesy of the Culpeper Museum of History.)

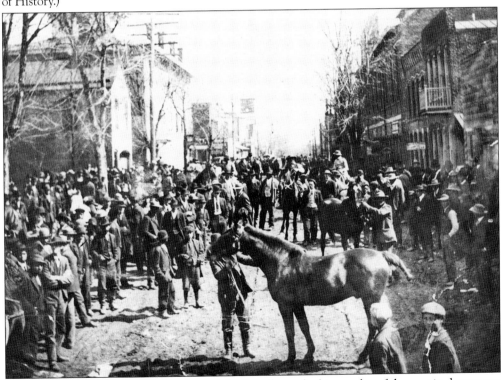

Court Day was held the third Monday in March and was the biggest day of the year in downtown Culpeper. This early-1900s picture was taken looking east on Davis Street. The only person identified in the picture is the man at the left with his arms folded. Dudley Edwards was the old lamplighter. (Photograph courtesy of the Culpeper Museum of History.)

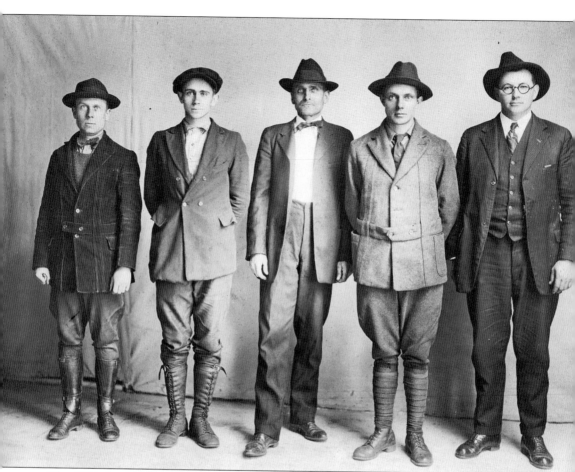

This 1924 photograph is of Culpeper Light and Power electricians. Pictured from left to right are Alfred Brand, Luther "Monk" Printz, Tom Howard, John Barber, and George Shaw. (Photograph courtesy of the Culpeper Museum of History.)

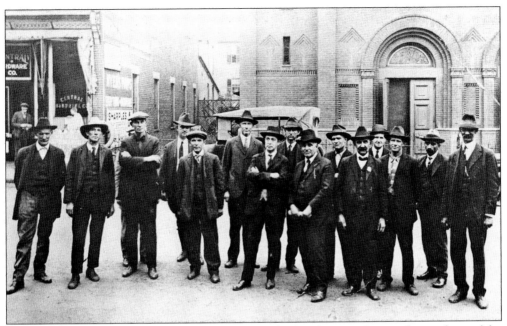

These men were jurors in an early 1920s murder trial. The photograph was taken in front of the Culpeper Baptist Church. (Photograph courtesy of the Culpeper Museum of History.)

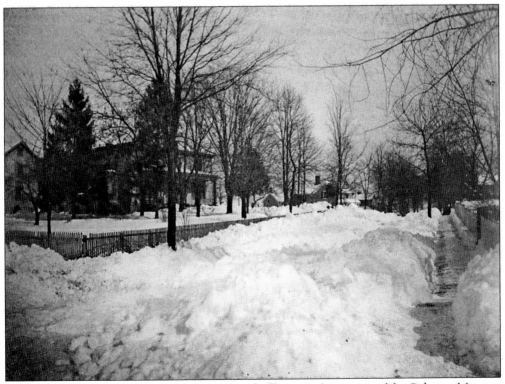

This scene is Piedmont Street in the 1899 blizzard. (Photograph courtesy of the Culpeper Museum of History.)

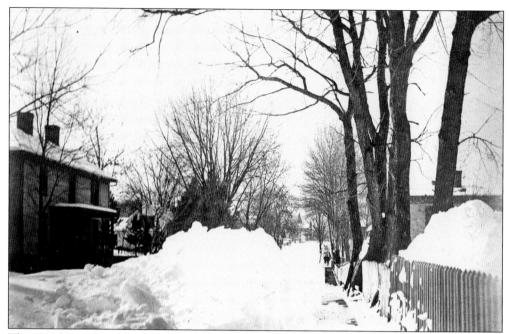

The 1899 blizzard was the largest snowfall witnessed by Culpeper. This photograph shows a scene on Piedmont Street. The picture was taken by J. T. Wampler, editor of the *Culpeper Enterprise*. Pictured at the near left is the T. J. Littleton home, and at the far left is the Nalle home. The steeple of the Catholic church on Main Street can be seen in the background. (Photograph courtesy of the Culpeper Museum of History.)

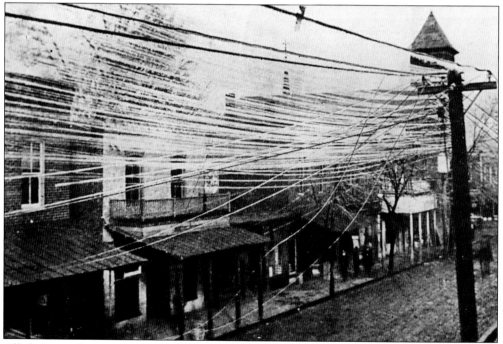

All the power lines in town were heavy with ice in the 1899 blizzard. (Photograph courtesy of the Culpeper Museum of History.)

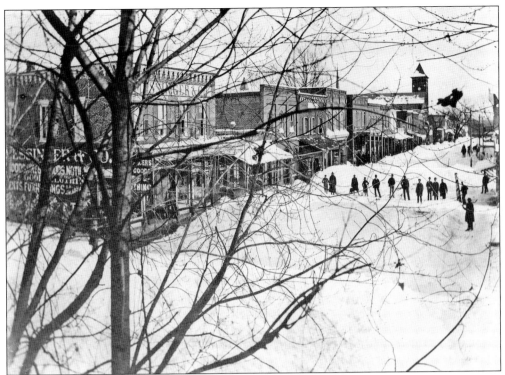

A snowy day is pictured on Davis Street in downtown Culpeper. The blizzard of 1899 was one of the worst winters in Culpeper history. On February 7, the snow began coming down, and it had become knee deep by the 11th. Temperatures plummeted to 15 degrees below zero for a week. (Photograph courtesy of the Culpeper Museum of History.)

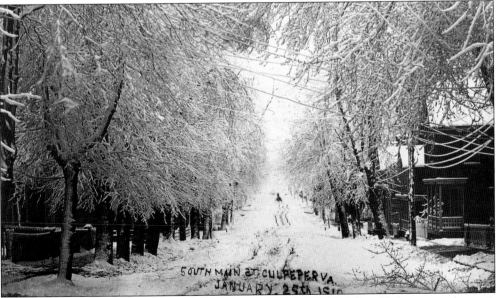

The view of South Main Street is looking north on a snowy day. The old Armstrong house is seen on the left. Many of the homes that are still here have housed various businesses over the years. (Photograph courtesy of the Culpeper Museum of History.)

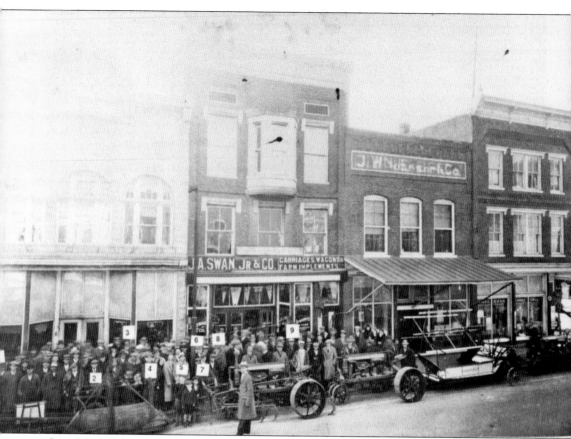

Swan's Day Sale was always a big event in Culpeper. This image was taken in the late 1920s. The Swan brothers were Culpeper's major implement dealers in the 20th century. Swan's Day became an annual event in 1930 and drew large crowds for several decades. (Photograph courtesy of the Culpeper Museum of History.)

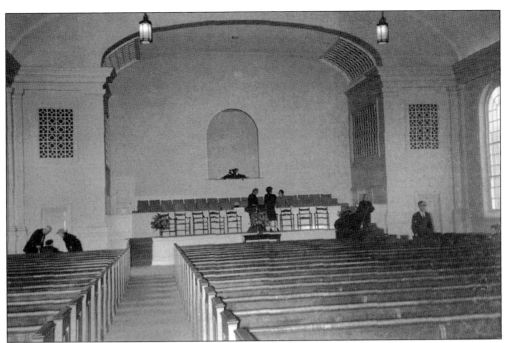

This photograph was taken following the dedication of the new sanctuary of the Culpeper Baptist Church. The dedication was attended by the Kinzers. (Photograph courtesy of the David Kinzer III collection.)

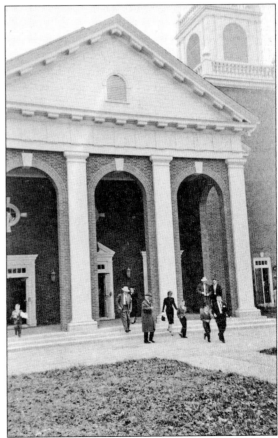

The Culpeper Baptist Church has been the traditional site for the Kinzers to be married. Pictured here is the Kinzer family following the dedication of the new sanctuary. (Photograph courtesy of the Kinzer family collection.)

The Reames Home was built by Fountain Fisher Henry. Henry was the original developer of East Street. The building has been moved east on its site twice: once in 1906 and again in 1995. (Photograph courtesy of the Culpeper Museum of History.)

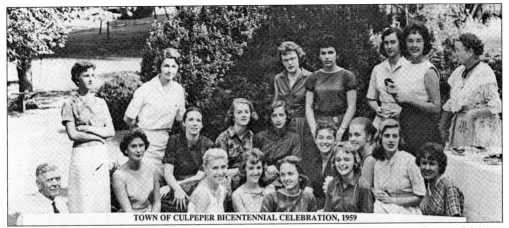

The town of Culpeper celebrated its bicentennial in 1959. From left to right are (first row) Mayor T. I. Martin; Betty Ann Reynolds, Princess of Orange; Barbara Ann Polk, Princess of Alexandria; Sharon Ann Leith, Princess of Manassas; Betty Jane Gibson, Princess of Charlottesville; Myria Anne Updike, Princess of Washington, Virginia; Emily Goolsby, Princess of Front Royal; and Marion Malone Watson, Princess of Stanardsville; (second row) Suzanne Marriott, Princess of Warrenton; Sarah Brokenbrough Willis, maid of honor; Jacquelin Morton Bragg, Queen of Culpeper; Carter Billingsley, Princess of Fredericksburg; and Peggy Jane Mitchell, Princess of Leesburg; (third row) Pat Fisher, Princess of Fairfax; Cherry Roth Gorham, maid of honor; Norma Sue Guinn, Princess of Culpeper; Betty Jane Ramey, Princess of Luray; Lois Aylor, Princess of Madison; Marjorie Winston, Princess of Louisa; and Mrs. T. I. Martin. The photograph was taken the backyard of Mr. and Mrs. T. I. Martin on East Street. (Photograph courtesy of the Culpeper Museum of History.)

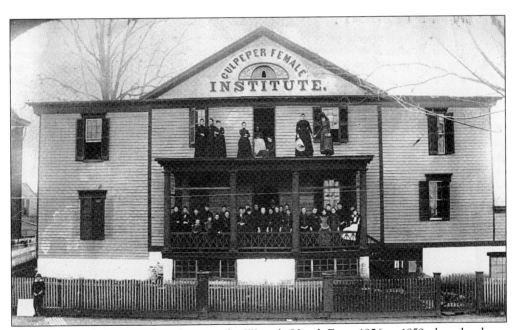

Culpeper Female Institute later became the Waverly Hotel. From 1856 to 1859, the school was operated by Rev. J. Walker George. It was converted into a hotel in 1905 and torn down in the early 1970s. (Photograph courtesy of the Culpeper Museum of History.)